experimental
painting

inspirational approaches for mixed media art

Lisa L. Cyr

NORTH LIGHT BOOKS
CINCINNATI, OHIO
www.artistsnetwork.com

acknowledgments & dedication

I would like to give special thanks to my wonderful editor Sarah Laichas and designer Guy Kelly as well as everyone at F+W Media who participated in the production and promotion of this book. Their excitement and willingness to embrace my vision makes a project such as this a true labor of love. In addition, I'd like to give thanks to my husband Christopher, my daughter Michaela and my two cats for their patience, understanding and assistance while I worked on this year-long endeavor. Lastly, I would like to recognize the One who always walks beside me in my journey, for I am forever His humble and faithful steward (Matthew 25:23).

I dedicate this book to my two grandmothers, my mother and my aunt for teaching me at an early age to embrace my creative spirit. In the spirit of embracing a childlike vision, I also dedicate this book to the other little flowers who have graced my life: Lucia, Jacinta, Theresa and Michaela. They inspire me to see the world with unobstructed clarity, encouraging me always to play, experiment and explore new ways to express and share my vision with others.

Title: Self Awareness
Size: 30¼" × 21¼" × 2⅜" (77cm × 54cm × 6cm)
Mediums: acrylic, oil, ink and graphite
Materials: textured paper, tissue, ephemera, dried flower, gold painted leaf, decorative metal accents and metal button
Techniques: collage, assemblage, dripping, sanding, scraping, peeling back, painting knife, tape resist and type transfer
Surfaces: linen canvas over Masonite and board with wooden framework

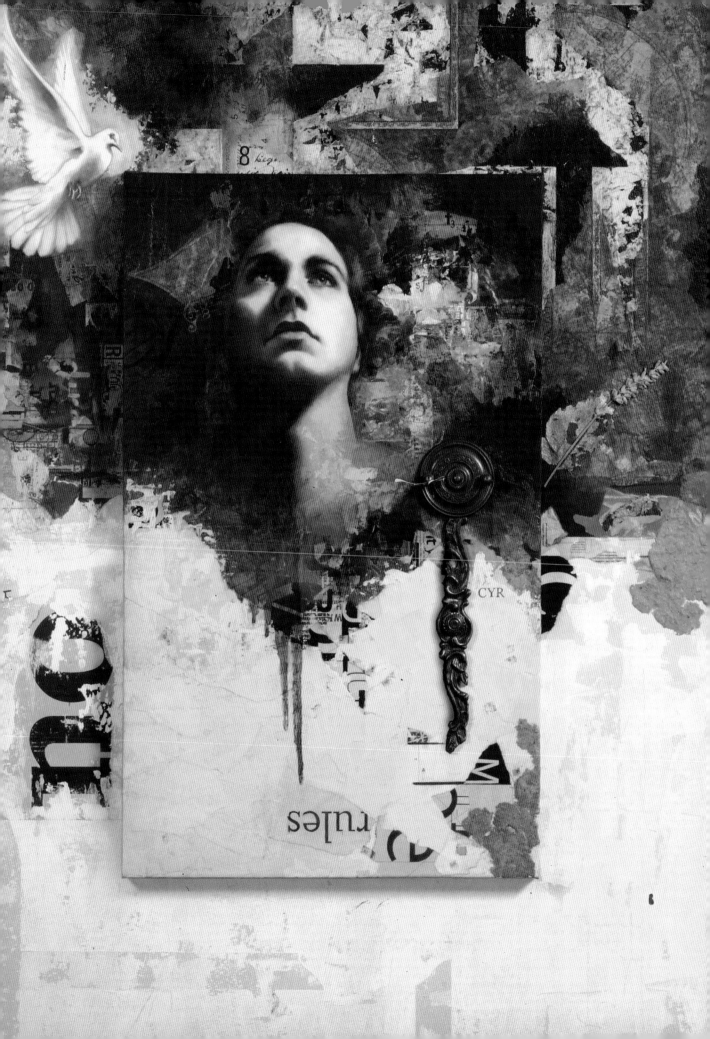

contents

SURFACES
Masonite
Linen canvas
Oak board
Polystyrene foam
Mill finish aluminum
Brass tooling foil
Printmaking paper
Illustration board: 4-ply
Bristol board
Clayboard panel
White bond paper
Tracing paper
Layout paper
Tissue paper
Handmade paper: fibrous
Transparent plastic sheets

DRAWING TOOLS
Graphite pencils
Graphite powder
Ebony pencil
Kneaded eraser
Adjustable eraser
Blending stumps
Conté sticks
Colored pencils
Fine point ballpoint pen

Technical pen
Waterproof black ink

PAINTING TOOLS
Flat, fan, bright, round and bamboo brushes
Sponges: natural and synthetic
Painting knife
Shaper tool
Sponge and textured paint rollers
Flat plastic and glass palettes
Plastic bottle with applicator tips
Hair dryer

PRINTMAKING
Brayer
Relief blocks
Rubber stamps
Ink pad
Embossing powder
Embossing ink pad
Embossing heat tool

SCULPTING TOOLS
Polymer clay
Wooden stick: sharp at tip
Wire
Carving tools
Rolling pin

Embossing stylus
Craft knife

PAINTS, MEDIUMS, SEALANTS AND ADHESIVES
Acrylic paint
Acrylic matte medium
Acrylic matte gel medium
Self-leveling clear gel
Resin sand texture gel
Molding paste
Modeling paste
GAC 200 and 500 acrylic polymers
Gesso
FoamCoat
Oil paint
Liquin
Mineral spirits
Vellum fixative
Bookbinder's glue: pH neutral PVA
Polyurethane construction adhesive
Wood glue
Frisket

EQUIPMENT
Desktop custom die-cutter
Hole and bindery punchers

safety guidelines

Before embarking on any new procedure or technique, it is important to be familiar with the products, equipment and processes you'll be using. The demonstrations throughout the book are for general instruction only and do not cover the risks associated with using art materials and tools. For health and safety procedures and product information, go to the manufacturers' websites or contact them directly to obtain the safety data sheets for all products and materials you use. Inhalation, ingestion or skin contact should always be avoided. As a general rule, never eat, drink or smoke when using art materials, and keep all products and equipment away from children. Ensure adequate ventilation in your studio and wear protective clothing, gloves and facial gear when needed. Also note that some processes described in the demonstrations use ink-jet and laser printers, scanners, cameras, copiers and other equipment in alternative ways that may void manufacturers' warranties. The experimental processes covered in this book have been developed by the author and no guarantee or warranty of fitness is offered.

work as play

Creativity is a gift that we are given and express instinctively as children. Without self-doubt or fear of rejection the inner spirit soars, embracing new experiences wholeheartedly. Eager to learn and always willing to try, children approach everything like it was for the first time. Sensuously aware and stimulated by even the most inconsequential things, the untempered mind explores the world in a way that is awe-inspiring to witness.

Oftentimes, as we move into adulthood, the inner realm gets overshadowed by the constant pressures, demands and distractions of the external world. We lose sight and no longer trust in the spirit of play that makes our unique gifts and talents shine. Easily bamboozled into thinking that doing something for the pure joy of it has no apparent purpose, we no longer see play as a relevant part of our process. In time, we become stagnant and creatively blocked.

To break free from the chains of self-induced boundaries, we must again dare to give ourselves the freedom to play, transcending to a time when the creative spirit reigned in a vast and seemingly limitless field of dreams. We need to remind ourselves what it feels like to be inquisitive, bursting with imaginative faculties. A pilgrimage back to a childlike, playful state of mind reunites us with the soul of our work: a bright, flickering flame that has always been present within. Without fear of mistakes or pressure to perform, we begin again, challenging ourselves to reach for new heights in our work.

As artists, our legacy lies in the ability to approach aesthetic endeavors with an authentic voice and vision, maintaining an intimate connection with the divine spirit that resides within. The expression of our gifts and talents is our unique contribution to world. To make an everlasting impact, an extraordinary mindset that is genuine at heart is needed to persevere, triumph and succeed with great rewards. The more we approach our work with insight, vigor and passion—continually cultivating creative play, exploration, experimentation—the more we are able to see and reach our full potential and inner greatness as creative beings.

Experimental Painting investigates exploratory methodologies, techniques and approaches in mixed-media art. Throughout the book, many in-depth demonstrations are featured, documenting cutting-edge mixed-media painting processes from concept to final execution. To offer an extensive array of visually stimulating possibilities for artists to explore, both two-dimensional and three-dimensional techniques are covered in a range of subject matter. Conceptual and thematic approaches include using symbolism, metaphor and allegory, incorporating pluralism and nonlinear storytelling, utilizing automatism and free-form painting, and employing costuming, props and theatrical settings. Developing works both in multiples and in a series is also included. In addition, special sections on creative exploration detail the playful act of experimentation, utilizing alternative tools, materials and techniques. By delving into the myriad applications of mixed-media painting, the creative process is reignited, opening a gateway for artistic works to grow and flourish.

To assist artists in venturing out on their own creative path with a unique voice and vision, topics on nurturing the creative spirit within, developing personal content through journalism, embracing a multidisciplinary mindset and creating message-driven art provide insight into the development of an artistic personality. The book closes with a chapter on creative self-promotion, revealing the latest marketing and presentation strategies for the working artist.

There is an ever-expanding interest in exploring unconventional processes and approaches to establish aesthetic distinction in the marketplace. For artists who are looking to push their work to a new level, this book will be a valuable resource and an ongoing source for creative inspiration.

Let the evolutionary journey begin!

A pilgrimage back to a childlike, playful state of mind reunites us with the soul of our work: a bright, flickering flame that has always been present within. Without fear of mistakes or pressure to perform, we begin again, challenging ourselves to reach for new heights in our work.

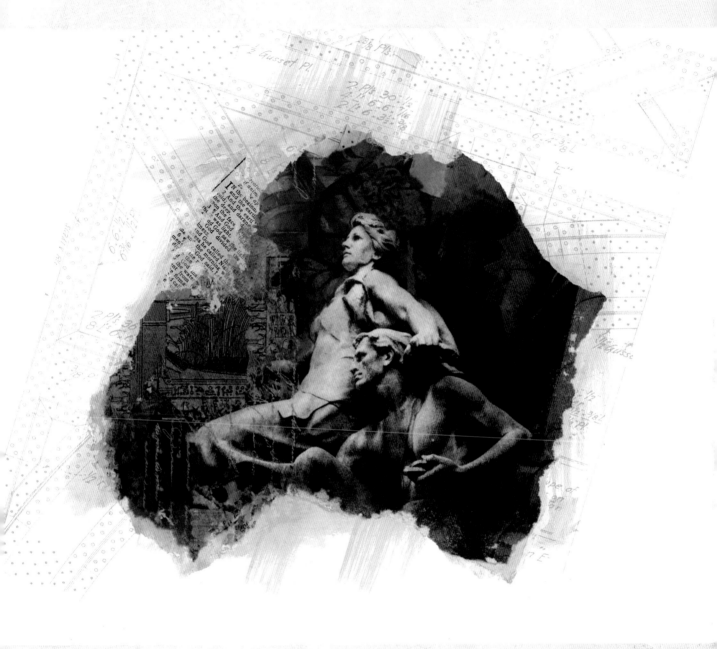

Title: Fortitude
Size: 9" × 8" (23cm × 20cm)
Mediums: acrylic, oil, ink and colored pencil
Materials: textured paper, tissue and ephemera
Techniques: painting knife, type transfer, printmaking, sanding and collage
Surface: illustration board

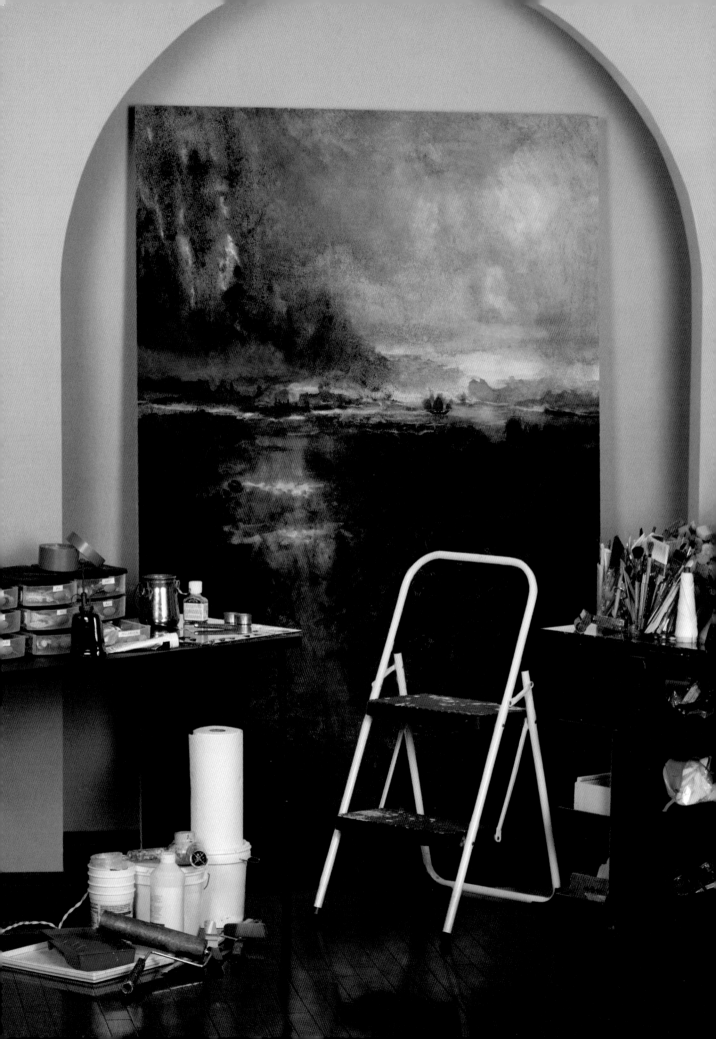

an exploratory process

Knowing what nurtures the creative spirit within is essential for ideation to ignite and artistic works to come to fruition. When fostering creativity, it is important to stimulate both the mind and the body. Every morning, rain or shine, I go for a brisk walk, approaching each day with vigor. The stimulation opens up my mental faculties and a stream of consciousness begins to flow. Things permeate my psyche, sparking a plethora of artistic ventures. From a series of paintings to a new book, article or traveling lecture, my mind is open to prospective projects. At the point of ideation, everything is possible. To keep a record of my thoughts, I'll often bring a tape recorder with me as I walk, later transcribing my thoughts to paper using voice recognition software. I find the practice to be an expedient way to log the outpouring of ideas that I experience. I don't always know where my random thoughts will take me, but I make a record just to see how they may manifest later on.

Whether I am taking a walk outside my studio on the East Coast, perusing the museums and galleries in New York City or traveling the country, I always come across something inspirational, encouraging me to somehow use what I have seen and experienced in my work. When I travel, I always take a mini sketchbook, journal and camera, as I never know when my muse may present herself. Outside the confines of the studio, intriguing textures, engaging constructs and luscious color palettes can be found almost anywhere. Europe is one of my favorite places to visit. I especially find delight in the extraordinary architectural, sculptural and design details that I encounter. Asia is also a favorite and I am an avid collector of furniture, dishware, costuming and the like from that area and hope to someday travel the countryside. Venturing outside the studio is an ongoing part of my creative process, as meeting new people and experiencing other cultures can be quite transformative.

I also find inspiration in the work of other artists. I especially admire the classical paintings of J.W. Waterhouse, William-Adolphe Bouguereau, Edwin Austin Abbey and John Singer Sargent. I absolutely love their romantic portrayals of the figure, whether it is religious or secular in nature. On the other hand, I am completely drawn in by the decorative, decadent and idealized art of Gustav Klimt and Alphonse Mucha as well as the innovative, multilayered, mixed-media combines of Robert Rauschenberg. I am also enamored by the pioneering works created during the Modern Art Movement. Artists challenged conventional ideologies and approaches, opening the door to alternative ways to interpret and communicate with the world through art. My understanding of what is possible has been enriched by their discoveries. I've often wished that I could take a ride through time just to meet or apprentice under such visionary artists. But, with that not being possible, I am driven to look at my own existence in time in search of the opportunities that it provides.

The older I get, the more aware I am of what feeds my soul. I know what inspires and motivates me and I know what discourages and distracts me from my path. Over my career, it has been a challenge to stay in tune, sustaining an even keel. The more I can maintain my focus on the work and not on all of the pressures and demands of the outside world, the better able I am to perform. The struggle is in keeping the two polar existences at bay. I find that if I live and work in the moment, then I am more likely to make the magic happen.

Innovation Through Experimentation

Every attempt at the easel presents an opportunity to explore, reaching beyond pre-existing barriers and limitations. In order to succeed, artists must be internally courageous, even willing to fail at their attempts. Only then are they really pushing themselves outside the comforts of set patterns and routines to pursue the unexpected. To continually expand my visual vernacular, I experiment almost every day, exploring new tools, materials and processes from a child's eye. Without a

Happy accidents happen when I begin to take chances and challenge the unknown. Things that I could not have predicted occur. I find that when I begin to play, I open the door for discovery to enter, creating a Pandora's box of divergent thinking and technical innovation.

When working large, I'll often put work against a wall and use a step stool to reach all areas of the piece. Pastel, charcoal, acrylic, oil and other mixed media make up this 6' × 4' × 2" (183cm × 122cm × 5cm) work-in-progress entitled *Night Fury*.

My studio is designed to not only support my process and approach but also inspire and uplift my creative spirit.

To keep the creative juices flowing, it is important that the working environment be an external expression of an artist's personality, providing an ever-evolving means of visual, verbal, tactile and even aromatic stimulation. A dynamic and continuous flow of energy that heightens and entices the senses provides a visceral playground for the mind.

set intention, I create. There is never any pressure to make the work portfolio-quality in the end, as that is not the intent. My creative exploration is purely an attempt to focus on the journey and not the destination. Happy accidents happen when I begin to take chances and challenge the unknown. Things that I could not have predicted occur. I find that when I begin to play, I open the door for discovery to enter, creating a Pandora's box of divergent thinking and technical innovation. Stepping outside my process to look for alternative approaches not only jumpstarts my creativity but also helps me resolve problems that had been challenging me. What I learn by experimenting, I bring into more finished works in an informed way. My ongoing experimentation has led to the development of a highly sophisticated visual language.

The Studio Experience

To keep the creative juices flowing, it is important that the working environment be an external expression of an artist's personality, providing an ever-evolving means of visual, verbal, tactile and even aromatic stimulation. A dynamic and continuous flow of energy that heightens and entices the senses provides a visceral playground for the mind. When I work, I like to create a certain atmosphere in the studio. If I am writing, sketching or composing, I like to light scented candles throughout the space. Engaging the senses heightens the experience for me. While painting, I enjoy

instrumental, new age and classical music. I especially love listening to scores created for the big screen. Their ability to conjure stories and induce surrealistic, dreamlike pictures in my mind ignites my imagination. Romantic poetry and literature also beckon me to other worlds and I am completely drawn in. I drift off to another place and time, venturing outside myself into the world of the fantastic.

My cathedral ceiling studio is arranged in a way that suits my process and approach. It is decorated with things that I've collected over the years, including a series of handmade dolls from around the world, several vintage typewriters, antique furniture, decorative lamps with custom shades, handcrafted lace tablecloths and pillows as well as other nostalgic objects that speak to me in some way. Many of the signature items in my studio were made especially for me by my two grandmothers, mother and aunt who could all sew, knit, crochet and embroider really well. Growing up, there was always extra fabric, thread and yarn around for me to play with. Early on, it became quite clear that something handmade was a gift from the heart, something special that was truly one-of-a-kind. Each piece serves as a reminder of the importance of sharing one's gifts with others and the impact it has on generations to come. This is a blessing I have passed on to my daughter, who shares her talents by making special handcrafted books with unique stories told inside. Although she is still very young, she aspires

to be a children's book author and illustrator, creating inspirational stories that will uplift the spirits of children around the world. With her father being a successful illustrator and animator, she also hopes to someday bring her stories to the big screen.

When I paint, I work on a large easel, on the wall or on the floor. The location is dependent upon the size of the work and the processes I am employing. If I am using water-based media, I prefer to use a stay-wet palette to keep the paint moist. For oil painting, I use a large piece of heavy glass, placing either a neutral-toned or colored paper underneath. The choice is based upon the color scheme that I've keyed the work on. To house my art supplies, I have a custom walk-in closet with floor-to-ceiling storage. Decorative boxes, figurative sculptures, an extensive reference library, my journals and sketchbooks as well as my vast collection of trinkets adorn the shelves.

To keep inspired, I have an extensive library of books that I love to peruse while sitting in my

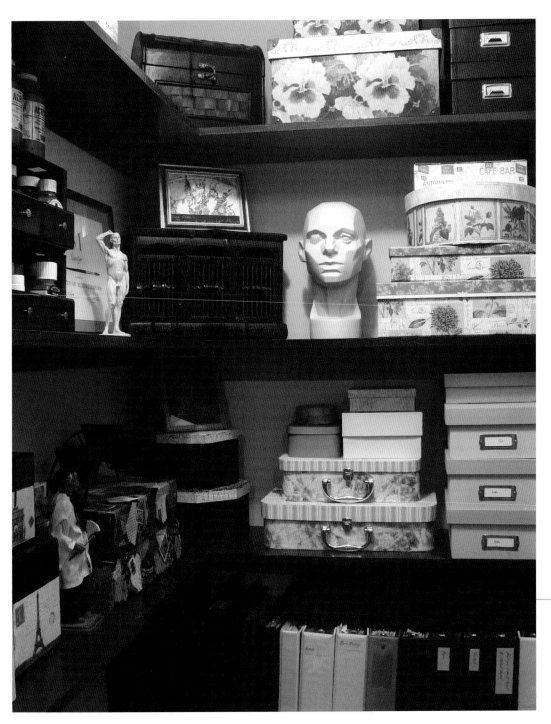

A custom walk-in closet with floor-to-ceiling shelving houses my art supplies, materials, tools and surfaces, sketchbooks, journals and an extensive reference library.

grandmother's old chair next to the window. From my studio, I have an expansive view of the outside, full of greenery and flowering trees. The native wildlife in my area is quite a treat, especially for a city girl like me. It's common to have deer and rabbits grazing in the yard while I am working. Hummingbirds, blue jays and red cardinals often land on my windowsill for a visit. Nature serves as a wonderful source of inspiration in my work. In my mixed-media art, I often use the natural elements that surround my studio as tools for painting, debossing, blotting, imprinting and other processes. Inside the studio, I have a large wall that is covered with intriguing imagery, textures and ephemera that I have accumulated over the years. It is an amazing montage of eye candy that I get to look at daily. Every time I travel, I find new things to put on the wall, rearranging the space each time like an ever-evolving wall collage. In addition, I have a words-of-wisdom board that I call the W.O.W. factor. It is where I pin up thought-provoking quotes that uplift my spirit. I am always inspired by the life experiences of extraordinary people. I find their insight to be empowering. By immersing and surrounding myself with elements that motivate and inspire, assimilation into the creative process becomes ongoing. The things that penetrate my mind, eventually find their way into my work in some extraordinary way.

To continue to grow as artists, it is important to pursue new ways of thinking and working. Seeking alternative means of creative expression allows for a more expansive ideation to enter the creative process, deepening one's frame of reference as to what is possible.

A Multidisciplinary Mindset

Looking outside one's creative discipline can often boost creativity, allowing divergent approaches to enter the process. From sculpture, design and architecture to theatre, film and music, alternative practices can spark creative momentum. Cross-pollination amongst the disciplines creates a dynamic, multi-sensuous smorgasbord conducive to the pursuit of new pathways in aesthetic exploration.

Every year, I always make it a point to venture beyond my own creative repertoire. Whether it be through my art or my journalistic endeavors, I spend time exploring untapped territory, looking at the world through a different lens. To document and share my insights, I've written hundreds of articles and several books, delving into a plethora of creative venues. I collaborate with an array of multitalented artists and designers from around the globe, keeping me in tune with the trends and the creative pulse of the international marketplace. My research ranges from revealing important issues that face the creative industry to profiling top talent in the business. From the fast-paced, forward-thinking worlds of cutting-edge design, illustration and fine art to the inner workings of the exciting fields of animation and interactive storytelling, I've been able to profile groundbreaking work, experiencing artis-

Shown is a detail of an acrylic painted textural ground that utilizes rip paper collage, debossing and sgraffito into coarse molding paste and resin sand-texture gel applied with a painting knife for a scumbling effect.

Aged surfaces, vintage finds and weathered effects of the natural environment inspire and spark my creativity.

tic expression through the eyes of some of the world's leading creative visionaries. I've had the opportunity to visit studios and watch some of the best in the business. In addition, I speak across the country at art organizations, industry conferences and universities giving lectures, workshops and other events. I meet so many people from a multitude of creative disciplines. I am rejuvenated by their motivation, passion, energy and ability to continually thrust creative expression to a higher level. My collaborative experience has been rewarding, fulfilling and enlightening, playing an integral part in my development as an artist.

Today, innovation is abounding. There is an unprecedented array of media available, creating an opportunity for artists to further push the envelope of visual expression. To continue to grow as artists, it is important to pursue new ways of thinking and working. Seeking alternative means of creative expression allows for a more expansive ideation to enter the creative process, deepening one's frame of reference as to what is possible. Multidisciplinary exploration breaks down the walls of stagnation to open new avenues for artistic works to move and grow, filling the cup of creativity for years to come.

VISCERAL AESTHETICS: 16
THE VOICE WITHIN: 7
MONTAGE, COLLAGE & ASSEMBLAGE: 23
PARADIGMS: 15
ENIGMA: 5

FIGURE AS METAPHOR: 25
JUXTAPOSITIONS: 7
LITERAL INTERPRETATIONS: 10
INSIDEOUT: 21
IMPROVISATIONAL: 5
CONFESSIONS OF A MIXED MEDIA ARTIST: 2
VISUAL POETRY: 5
ART + LIFE: 3
FRAGMENTS: 23
CACOPHONY: 1
PARADOXICAL PASSAGES: 20

ON THE EDGE: 4
ILLUMINATIONS: 17
FIGURATIVELY SPEAKING: 19

conceptual ideation and development

Ideas ignite from within, prompted and propelled by one's interests and surroundings. The manifestation comes to the surface only when all the necessary components are available to bring it to fruition. The coalescing of the internal and external spurs an inspired thought to take flight, and it is up to the artist to recognize and make sense of the relationships that begin to unfold once it surfaces.

Researching the Subject

Expanding upon personal knowledge and experience can often enhance the process of conceptual development, allowing new insight and information to enter into the mix. When I am trying to delve into a specific subject, I look to my journals, sketchbooks and research to stimulate ideation, breathing new life into both my conscious and subconscious minds. I like to adorn the pages of my journals, sketchbooks and altered books with collage and painted passages. The visual stimulation helps with my creativity.

Today, information is abounding. The library, a great bookstore or the World Wide Web can assist in providing a fuller understanding of any topic, from a contemporary as well as an historical viewpoint. I often use a software-driven unabridged dictionary as well as a visual thesaurus to see myriad interpretations. In my conceptual ideation process, I go through a series of creative problem-solving steps I call progressive refinement. With my investigative research at hand, I commence with written notations, expanding upon what I have unearthed and making connections amongst the various disparate details. The renditions are vast and my job is to hone in on a direction that I can feel personally invested in. By engrossing myself in a topic, I am able to make a connection that is passionate and inspired.

Ongoing journaling provides not only creative inspiration, but also a wealth of reference material for both stand-alone pieces and works in multiples and series.

Working Out the Composition

Once it is clear in my mind where I want to go with an overall concept, I make lots of preliminary thumbnail sketches, searching for just the right composition that ignites my creative instincts. At this stage, I try to avoid getting too detailed or committed to any one design too early. Instead, I remain open to the process and willing to explore various pictorial formats, settings, spatial relations and points of view. When I am working on thumbnail sketches, I prefer to use tracing paper and an HB graphite pencil. I like taking a new sheet of tracing paper and quickly placing it on top of one or more of my thumbnails to make quick adjustments or alterations. Using the tracing paper allows me to work as fast as my brain is thinking. Once I begin to see a compositional layout that interests me, I scale up the sketch and begin to work out the finer details of the setting, pose, facial expression, hairstyle, costuming, props and embellishments.

Although my poetic, imaginative compositions originate from within, I rely on photography and preliminary studies to assist me with the more representational areas of my work. To develop a more refined and delineated sketch, I gather reference. Life studies, on-location drawings, journal notations, photographs and video clips can provide valuable information creating a level of believability in my work. When photographing reference, I use a high-resolution digital camera, an adjustable tripod, umbrella reflectors, softbox diffusers, modeling lights and a four-head strobe system. Although I shoot in color, I transfer the digital images to grayscale when working from them. I prefer to invent my own color and don't like being too heavily influenced by the existing palette in the reference photos. I love digital technology, as it allows me to see the various exposures instantaneously without the delay that print or slide processing involved.

I begin each shoot with a certain composition in mind, yet still remain open to the magic that happens behind the camera when it comes to other possibilities. With photography, I do a lot of improvisation. Using various camera angles, I take lots of shots, exploring lighting, body language, facial expression, costuming and prop options. I use models and basic costuming

When I am trying to delve into a specific subject, I look to my journals, sketchbooks and research to stimulate ideation, breathing new life into both my conscious and subconscious minds.

to provide enough information to make an initial sketch that I can later embellish. To assist me, I collect lots of swatches of decorative lace, trim, ribbon, rope, buttons, costume gems and fabric. I refer to these samples when adding detail to the clothing of my characters. I also have a diverse collection of historical costuming and vintage textile design books to peruse when I am developing a figure-driven work of art. Creating makeshift props out of foam, cardboard, papier-mâché or self-drying clay can serve as great stand-ins during a shoot. Surface detail can always be applied later in the drawing and painting stages. In addition, I have a vast reference library of body types, facial features and hairstyles from past photo shoots to help adjust my initial drawings to best fit my vision. Because I often need multiple pieces of reference to construct not only the figurative elements in my work but also the still lifes, landscapes and environments that I envision, I have accumulated quite a large library. I look to my diversi-

fied collection that is organized by category anytime I need to ground my subject in reality. With every project, I continue to feed that resource with new material.

Employing Value and Color Studies

Making preliminary studies can be a valuable investment, allowing numerous possibilities in color and tone to be explored prior to doing a more finished work. Creating studies helps explore mood and create drama in a work. I tend to adhere to a one-third to two-thirds ratio. In regards to value, my pictures will be either one-third light and two-thirds dark or two-thirds light and one-third dark. I find the contrast establishes a more definitive disposition in the work. To make a series of value studies, I scan my line art sketch into the computer, print out several ink-jet copies onto bristol board and tape them to a hard surface using painter's tape. I use powdered graphite and a chamois cloth to spread the graphite evenly onto the entire surface

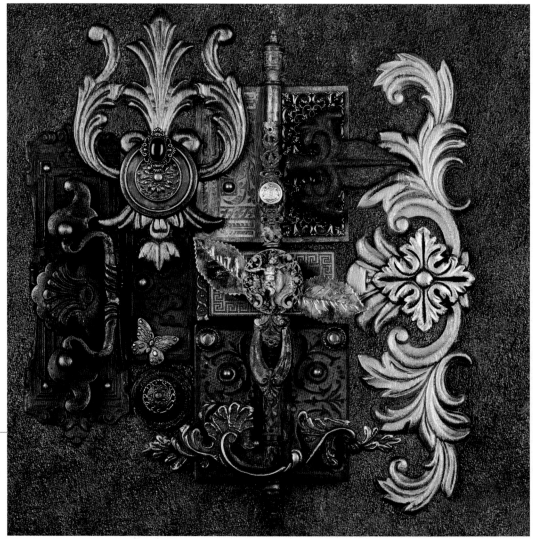

Wooden and metal architectural accents as well as ornamental hinges, handles and door knockers can be creatively used as visual references for a variety of subjects.

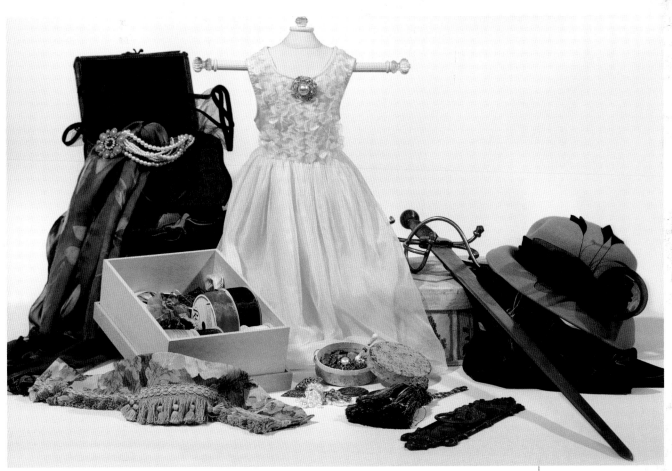

A miniature dressmaker's mannequin stands amidst a small sampling of the props, fabric, jewelry, architectural accents, decorative trim, lace, beads and other objects used as costuming references for my figurative works.

of each drawing. This establishes a midrange tone. I then use a kneaded eraser to establish the lights and a variety of soft graphite pencils to establish the darks. I use an Ebony pencil for the really dark tonal areas. The smooth surface of the paper and the malleable powdered graphite medium allow me to work quickly. I usually make the areas in the light a little lighter and the areas in the shadow a little darker, allowing for color to be applied later.

When I've captured the right value range that conveys the mood I am looking for, I scan the drawing into the computer, adjusting the monochromatic study to key in on a particular color. For instance, instead of gray, I'll change the color scheme to blue, green or purple. I'll print out the colorized studies onto printmaking paper, taping each print onto a hard surface with painter's tape. I then apply two to three layers of acrylic matte medium on top with a brush, sealing the surface. When they are dry, I paint each of the various key color schemes with acrylics and oils. Having a variety of hues available in a full value range allows me to experiment with completely different color options at the same time rather quickly. I work a lot in complementary or

split-complementary color palettes. I like the dramatic, almost theatrical effects they create. When it comes to color, I think mainly in temperature, utilizing the same one-third to two-thirds ratio for both warm and cool. I like to use color as an emotional component in my work. The psychological properties inherent to each hue, whether historical or cultural in nature, can be quite effective as a communicative device. Reds, for instance, are the color of vigor, energy and heat. Our eyes are instantly drawn to the hue with urgency. Greens on the other hand are the color of nature, healing and strength. Although we are not immediately drawn to the hue, greens remain ever present. We see them in great distances and our eyes never grow tired of its majestic beauty. Both the value and color studies I create are used as reference material when producing more formal works.

Message-Driven Art

To captivate an audience, artistic endeavors need to allow room for imaginative interpretation, inviting the viewer to personally engage in the work. Active or cognitive participation by the onlooker often leaves a

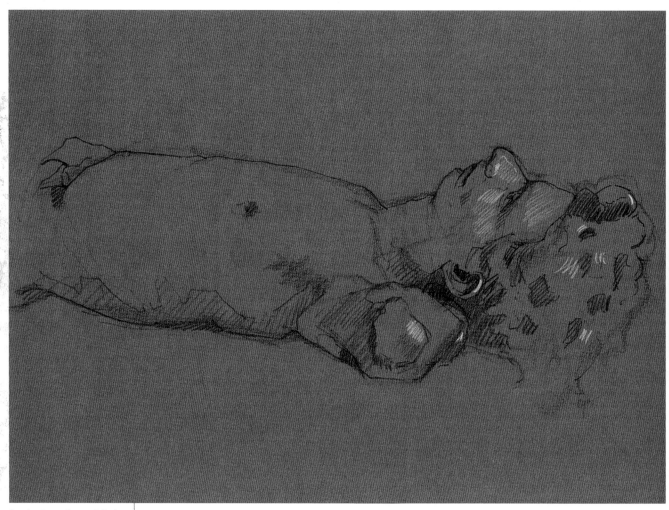

Drawing from a live model helps to create a connection and understanding of the human form that can be invaluable when you want to include the figure in more imaginative works. This life study of a reclining male nude was drawn with graphite, an Ebony pencil and a white Conté stick on colored paper.

long-lasting and memorable impression, one that will often resonate over generations.

In my work, the concept and messaging always dictate the approach, composition, palette, tone and materials chosen. My use of unconventional materials and processes is purposeful and not for mere stylistic fancy. Over my career, I've learned how various materials and techniques can evoke innate, almost universal responses based upon their inherent properties and the cultural as well as historical connotations attributed to them. I use this knowledge in my work to yield a sense-based reaction. By appealing to the senses, I am able to speak to the viewer in an emotionally driven and visually compelling way. For instance, if the overall concept of a piece is about anger and resentment, the materials will be hard-edged, sharp and man-made. The application of mediums to the surface will be erratic, unwieldy and destructive, perhaps scratching in, peeling back or digging into the surface to expose

layers hidden below. The mark-making will appear jagged and the overall tone of the piece will be high in contrast. Emotionally driven works grab the viewer by igniting the senses and challenging the intellect, encouraging deeper inspection and even participation in the overall messaging. Through the unification of content, process and materials, the artistic work is transformed. Whether I am drawing, painting, writing, teaching or lecturing, my work is all about communicating with an audience, establishing a dialogue to make a meaningful connection.

To create a dynamic and robust exchange, visual expression must be continually put into question. An ever-evolving reinterpretation of the way art can be intellectualized, produced and presented into the culture needs to be top of mind. With an expansive ideation and inventive mindset, artists will push the envelope, creating a new vitality in aesthetics and popular culture.

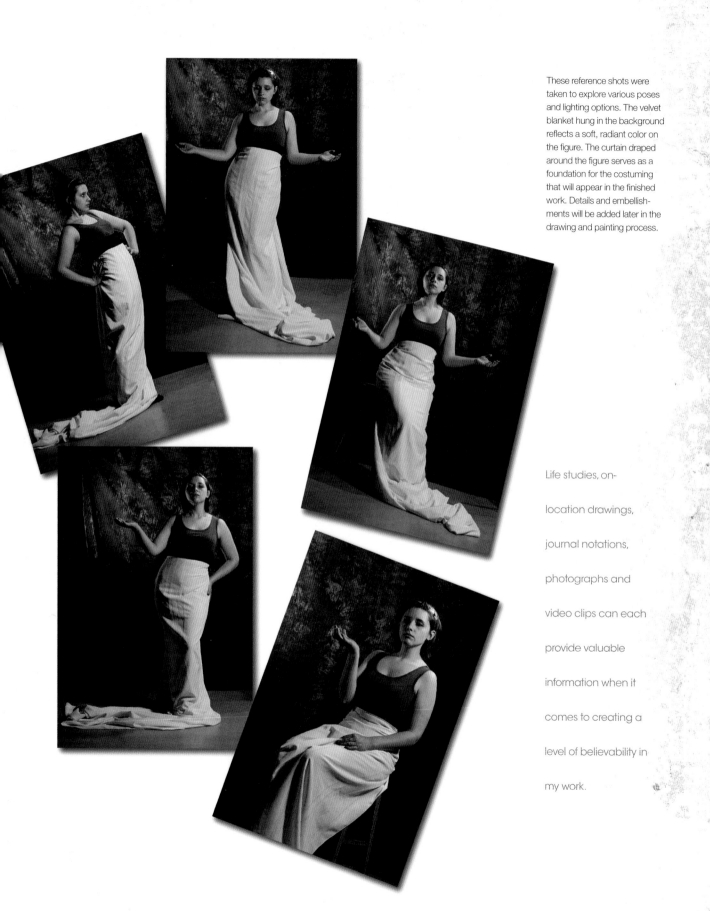

These reference shots were taken to explore various poses and lighting options. The velvet blanket hung in the background reflects a soft, radiant color on the figure. The curtain draped around the figure serves as a foundation for the costuming that will appear in the finished work. Details and embellishments will be added later in the drawing and painting process.

Life studies, on-location drawings, journal notations, photographs and video clips can each provide valuable information when it comes to creating a level of believability in my work.

unconventional surfaces, materials and tools

To expand their creative repertoire, artists are experimenting with a vast array of unconventional surfaces, materials and tools, pushing the painting ground to take on a more active, visually expressive role in the cognitive interpretation of a work of art. In the new spatial continuum, every material, surface and mark-making apparatus has an inherent communicative potential just waiting to be revealed. The choice to use one substrate, tool or technique over another is never random but quite deliberate. Ever mindful of the conceptual intent, each conscious choice becomes part of a collective whole in the overall reading of a work. With every aesthetic exploration, the pictorial surface is reinvented, embracing alternative ways to provoke, engage and communicate with an audience.

Exploring Alternative Substrates

When it comes to choosing a surface from which to work, mixed-media artists are venturing outside the discipline. They are looking beyond the traditionally accepted substrates such as hardwood, Masonite, canvas and paper in search of grounds that can enrich their work by providing a unique sensory experience. With the use of sizings, primers, fixatives, sealants and receptive coatings, almost any surface can be introduced into the mixed-media painting milieu. Both flexible and rigid alternatives are being explored in creative combinations, establishing an entirely new, more inventive vitality in the overall anatomical structure and framework of the picture field.

The coalition of porous and nonporous surfaces within the same work provides an unexpected combination of absorbencies and surface tensions. In addition, many substrates allow for processes such as molding, carving, etching and embossing to be introduced into the mix, transforming the surface by adding depth and dimension. The distinctive properties present in unconventional substrates such as metal, plastic, fiberglass, polystyrene foam, wire mesh, glass and the like offer intriguingly tactile, sensory-charged environments in which to further develop a subject.

Although utilizing unconventional working grounds can open a plethora of visual possibilities, they can also present constructional limitations, paint adhesion issues and concerns when it comes to long-term permanence. It is always best to test any unorthodox surface first before committing to a more finished work of art. Consulting industry manufacturers or downloading material data sheets online can also help determine the reliability of a surface.

Experimenting With Tools

In addition to the ever-changing role of the artistic working ground, the instruments with which to adorn the surface have also evolved and expanded to encompass a wide range of altered, repurposed and custom tools. When it comes to discovering fresh, alternative ways to apply and manipulate painting mediums, traditional brushes, painting knives and rollers are playing second fiddle to sponges, squeegees, trowels, putty knives, pastry decorating utensils, combs, toothbrushes, eyedroppers, sticks, straws, basting syringes and plastic bottles with various applicators. Almost anything can be used as a tool for artistic expression. Artists just need to look around their environment and be open to what they see every day.

The aesthetic use of unconventional tools opens the door for signature applications, creating an interesting dichotomy when introduced alongside more traditional artistic approaches. When a pictorial surface is infused with alternative mark-making, it stands apart and becomes fresh and original. Artists are no longer limited to what the art manufacturers offer. They are creating their own set of custom tools, individually tailored to a way of working that is personal to each artist.

The aesthetic use of unconventional tools opens the door for signature applications, creating an interesting dichotomy when introduced alongside more traditional artistic approaches.

An altered brush adds unique marks to the richly painted surface.

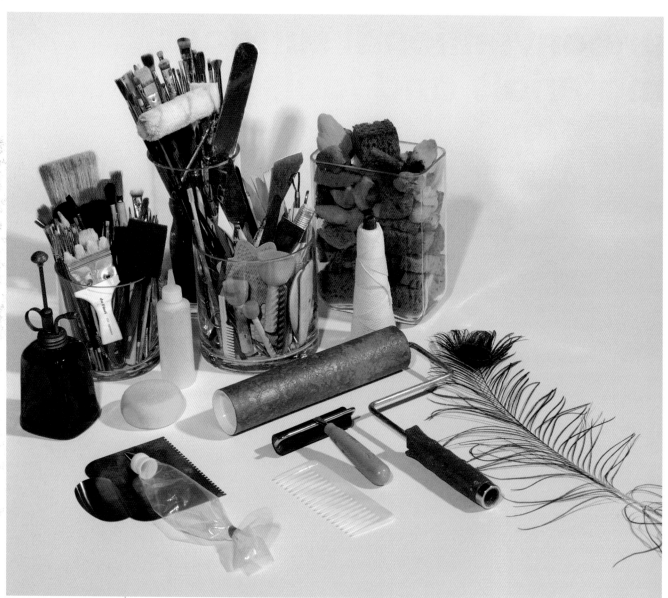

A combination of traditional, altered, repurposed and custom tools are employed in my mixed-media works.

Innovative, alternative and unorthodox tools create an even greater range of possibilities for the mixed-media artist's already abounding arsenal of techniques.

The Resourceful Artist

To foster creative innovation, artists must continue to look beyond their own processes and approaches, being observant, resourceful and open to the myriad possibilities outside the confines of the studio. From the construction, medical and automotive industries to the fashion, textile and culinary arts, a vast array of alternative surfaces, materials and tools can be repurposed and assimilated into the visual vernacular. Defying convention opens the door to creative ingenuity, establishing a new visual touchstone and an enriched language for all to share.

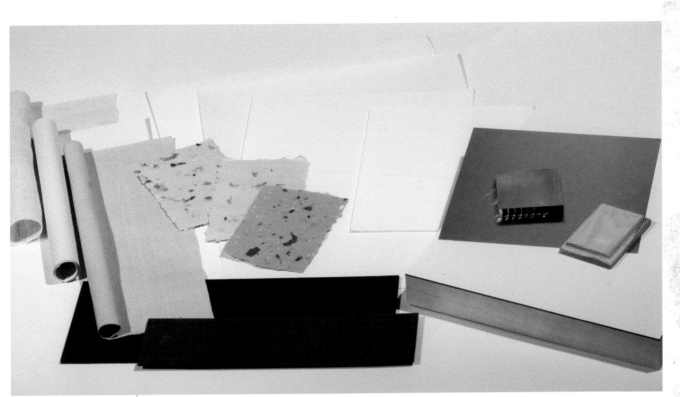

From flexible substrates such as primed linen canvas, raw cotton duck canvas, burlap, handmade papers, printmaking paper, watercolor paper and bristol board to rigid grounds such as illustration board, embossed sheet metal, honeycomb aluminum, Masonite, wood and Clayboard, a plethora of surfaces is available to the mixed-media artist.

The distinctive properties present in unconventional substrates such as metal, plastic, fiberglass, polystyrene foam, wire mesh, glass and the like offer intriguingly tactile, sensory-charged environments in which to further develop a subject.

altered, repurposed and custom tools

When it comes to creative distinction in mark-making, altering the traditional painting instruments, repurposing tools from myriad disciplines and inventing new devices for custom treatments is at the cutting edge. The tendency to isolate tools to a specific task is waning, and new methods are being used to push the boundaries of pictorial expression.

Altered Tools

Many of the traditionally accepted painting tools such as brushes, paint rollers, palette knives and painting knives are being altered to create unconventional applications. Using wire, tape or string, old brushes are finding a new purpose. Wrapping a brush so that the hairs are separated in an organic fashion will result in strokes that are more irregular and random when paint is applied to the working surface. Cutting into the strands of a flat brush or creating a new brush with string, rope, thread or hairs pilfered from an old brush can also produce interesting effects. I never throw away damaged brushes. I have always been able to find an alternative use, extending the range of capabilities. I've trimmed several of my bristle brushes that have been worn down, making them into the perfect tools for blending powdered graphite into a textured ground. Many of my frayed synthetic brushes have become prime candidates for creative wrapping and restructuring. The organic imprint they make allows me to produce textures that I would not have been able to achieve using more conventional means.

Palette and painting knives can also be creatively transformed. Adding things like paper clips to the tip and securing them in place with tape makes for an interesting tool for manipulating paint, gel medium, molding and modeling paste. The wire of the clips can be easily rearranged and altered, creating an infinite number of options to explore. Treated paint rollers can also offer freewheeling, random effects. By cutting into the surface or applying an additional material like string, rope, tape, cheesecloth or decorative lace to the roller, unexpected, distinctive designs can be created once paint or ink is applied on top. I love using treated rollers and brayers. When applied to a surface, they instantly create texture and depth. The protruding areas leave a more defined imprint while the recessed sections make a less distinctive mark, depending upon the pressure applied. Once multiple colors are introduced, the results can be astonishing.

Repurposed Tools

To further push and expand their creative repertoire, artists are looking to sources outside their studios and finding intriguing solutions. Utilizing nontraditional tools, they are discovering alternative ways to apply and manipulate various painting mediums on the surface of the working ground.

From sponges, toothbrushes, eyedroppers, nail brushes, sticks, basting syringes, straws and plastic bottles with various applicators to squeegees, pastry spatulas, rulers, brooms, forks, rocks, electronic fingernail files, hairbrushes and combs, scores of alternative tools are being repurposed. Using both natural and synthetic sponges, unique patterns are being introduced into the pictorial surface. Sponges are also great tools for blending and creating unique transitions. In addition, spattering is being employed in myriad ways. A toothbrush provides a fine, mist-like effect while an eyedropper can achieve more of an explosive appearance. Plastic straws allow for controlled blowing and dispersing of liquid mediums, intermingling colors in an unpredictable way. Stippling with a nail brush offers a Pointillist-like look, where color is optically mixed on the surface.

Pouring or dripping paint or gesso using a stick, basting syringe or plastic bottle with an applicator tip can add a dynamic, energetic quality that can also be quite dimensional. The use of a thick consistency yields heavier mark-making with a slow and controlled application while fluid mediums create finer, more elongated marks. I really love working with the drip technique, using acrylic paint, ink and gesso onto both wet and dry surfaces. Applying an acrylic medium or gel on the working ground before dripping commences can invite even more opportunities to play. I enjoy drip-

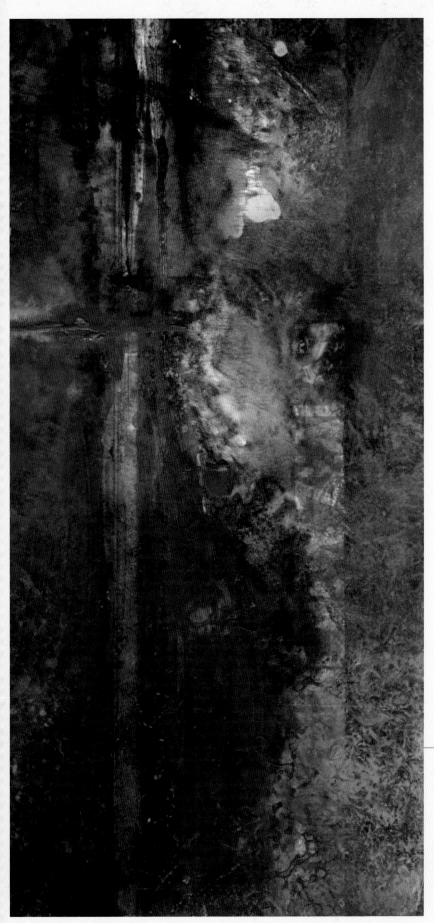

An imaginative environment is produced using several altered brushes, a sponge roller wrapped with cheesecloth and a brayer covered with several layers of ruling tape and vinyl letters. A custom cut, bendable plastic card is employed for heavier, more impasto-like effects.

ping various colors of liquid acrylic into self-leveling gel, later swirling the mix with a hair comb or stick to make a unique design. For a more impasto look, acrylic gel medium can be used as the base.

When it comes to spreading or dragging paints, pastes or mediums across large areas, squeegees, pastry spatulas and even metal rulers are the tools of choice. For creative mark-making into a wet surface, brooms, forks, sticks, hairbrushes and combs are being employed in creative combinations, generating distinctive results. Once the surface is dry, sandpaper, an electronic fingernail file or even a rock can be used to remove paint, revealing subsequent layers that lie below.

When my art transformed from smaller works to more grander formats, I had to seek out new tools to assist me in the process. No longer could I use the same instruments and obtain similar results. New ways of working had to enter into the mix. Repurposing tools from myriad disciplines has assisted me in the transition.

Custom Tools

In addition to altered and repurposed tools, a potpourri of custom-made devices is being explored to introduce aesthetic distinction into the pictorial surface. As a supplement to traditional painting approaches, custom tools offer artists the ability to create a unique signature.

Goose, turkey and duck feathers are being used as brushes, mailing tubes are being transformed into custom rollers, and die-cut cardboard and plastics are being employed as graining instruments. Exciting possibilities are just waiting to be explored for applying, manipulating or removing paint from the working surface.

Using unorthodox tools and materials, artists are expanding the boundaries of mixed-media painting. By exploring new territories, taking risks and breaking free from set attitudes and behaviors, alternative ways of working are being introduced into the practice.

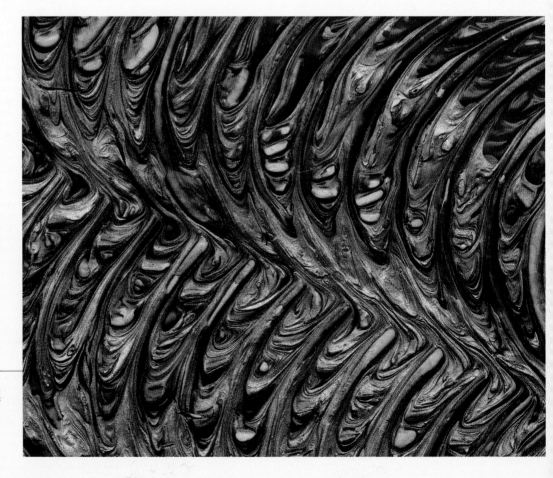

A dimensional, marbleized texture is created using acrylic matte gel medium and acrylic paints manipulated with a hair comb.

A string mop is used to manipulate and absorb paint in a dynamic way.

An abstract landscape is created using self-leveling clear gel, liquid acrylic and metallic interference paints that are dripped and manipulated with a feather onto tinted illustration board.

making a customized roller

Using everyday materials, custom tools can be produced to introduce signature mark-making and imprints onto the working surface. Further expanding the visual vocabulary, one-of-a-kind instruments allow for a distinctive, personal approach to picture making.

materials

Masonite ¼-inch thick (6mm)
Heavy-duty mailing tube
Decorative fabric lace
Relief blocks
Paint rollers: 4- and 9-inch (10cm and 23cm)
Paint roller handle
Pastry spatula
Metal ruler

Acrylic matte medium
Acrylic matte gel medium
Molding paste
White gesso

Flat nylon brush
Sandpaper
Cotton cloth
Hand saw

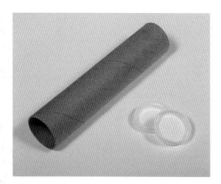

1 Making the Base
The plastic caps are removed from the ends of the mailing tube and put aside. Using a hand saw, a heavy-duty 2-inch (5cm) diameter mailing tube is cut to approximately 10 inches (25cm) long. A bigger trim size can also be used for larger works. Note: Bendable cardboard tubes will not work.

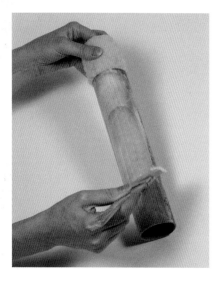

2 Coating the Surface
A 4-inch (10cm) paint roller is temporarily inserted part way into the tube. This is used as a holding device while the tube is coated. Three coats of acrylic matte medium are applied with a soft flat brush all around the tube to seal the surface. To establish the imprint base, acrylic matte gel medium is applied to the surface. A thicker application of gel medium will allow for a more dimensional texture while a thinner coat will produce a more subtle relief.

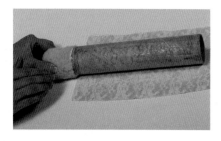

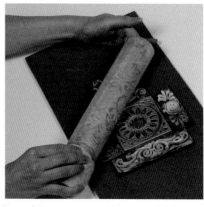

3 Creating the Design
While the gel medium is still wet, the tube is slowly but firmly rolled over a piece of fabric lace to deboss the surface with an overall texture. For more detailed areas, various relief blocks are also imprinted into the surface. Almost any material, porous or nonporous, can be used to create texture. The tube is dried overnight in an upright position.

Visit artistsnetwork.com/experimental-painting for a free altered tool demonstration

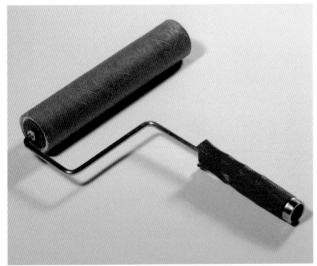

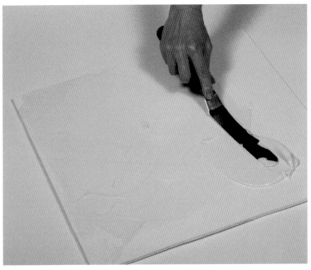

4 Assembling the Tool

Once the gel medium has fully cured, sandpaper is used to smooth out any unwanted peaks on the surface. The small roller is removed and a large 9-inch (23cm) roller with an attached handle is fully inserted. This will ensure an even distribution of weight and ease of use. One of the plastic caps is used to seal the other side of the tube.

5 Preparing the Substrate

A layer of molding paste is applied to a gesso-primed Masonite surface with a pastry spatula.

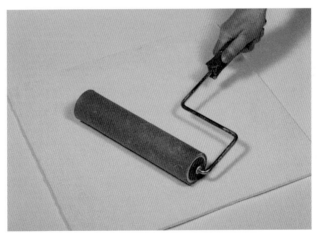

6 Smoothing the Substrate

A metal ruler is used along the vertical as well as the horizontal to thin down and evenly distribute the molding paste. A very heavy coating of molding paste will not work for this application.

7 Producing the Custom Imprint

The custom tool is employed by pressing it firmly on the surface and rolling slowly in various random directions, allowing the unique, textured pattern to appear. If any molding paste builds up on the tube, simply wipe away with a slightly damp cotton cloth. Since the tube is sealed, it can be cleaned with water and a nail brush and reused for other applications. When cleaning, the plastic caps should be inserted on both sides to protect the interior of the tube once the handle and roller have been pulled out.

experimenting with metal substrates

Metallic surfaces such as aluminum, brass and copper offer a dynamic range of hybrid possibilities to explore. From molding, sculpting, etching and embossing to the addition of patinas, metal-based surfaces introduce provocative, highly tactile ways to present pictorial content.

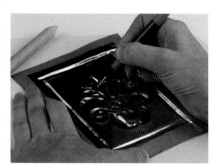

1 Embossing and Debossing Metal

Brass tooling foil is cut to size with scissors and taped around the edges with painter's tape. A line art drawing is debossed in the back using a ball point pen without ink. Using a metal stylus with a rounded tip, the metal surface is embossed on top of a soft foam rubber surface. For more linear detail, a sharpened stick is used with a hardwood surface placed underneath. A soft blending stump is used to smooth out areas. When complete, it is trimmed around the edges with a craft knife.

2 Preparing the Surfaces

A mill-finished sheet of embossed and debossed aluminum and the brass metallic accent are cleaned with a degreaser solution and a cotton cloth on both sides to remove any oil or grease. To allow paint to adhere to the metal surfaces, they are lightly abraded on both sides using steel wool. The debris is brushed away and the metallic surfaces are cleaned with a rag. Rubbing alcohol is used as final cleanser to prepare the surfaces for priming and painting. It is important to remove oil and fingerprints from the metal surfaces prior to priming.

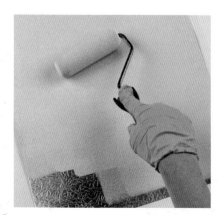

3 Priming the Metal Ground and Accent

For increased adhesion, the front sides of the metal surfaces are primed with three parts GAC 200 and one part GAC 500 clear acrylic polymers using a brush. The backsides are painted with several coats of a latex-based metal primer using a roller.

materials

Masonite ¼-inch thick (6mm)
Poplar wood strips ¾"× 1½" (19mm × 38mm)
Aluminum: mill finish
Brass tooling foil
Hardwood
Foam rubber

Acrylic gel medium
White gesso
Modeling paste
Red gesso
GAC 200 and 500 acrylic polymers
Latex-based metal primer (white)
Waterproof black ink
Degreaser
Isopropyl alcohol
Fine tip ballpoint pen without ink

Flat and fan brushes
Paint roller
Painting knife
Craft knife
Pastry spatula
Rubber squeegee
Brayer
Embossing stylus
Blending stump
Wooden stick: sharp at tip
Steel wool
Painter's tape
Scissors
Cotton rag
Paper towels
Wax paper
Heavy books
Screws

Visit artistsnetwork.com/experimental-painting for a free altered tool demonstration

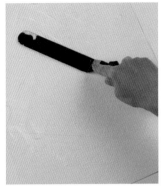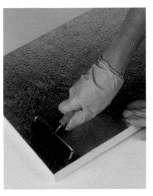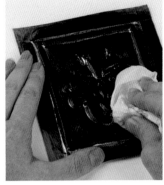

4 Adding a Rigid Substrate

Since the thin metal sheeting is prone to denting and bending, it is stabilized by adhering it to a rigid ground: a white gesso-primed Masonite panel screwed to a poplar wood framework. The back of the primed metal sheeting and the front of the dimensional substrate are coated with acrylic gel medium using a pastry spatula and a rubber squeegee to spread the medium evenly. While the surfaces are still wet, the metal substrate is applied on top of the dimensional base. A brayer is rolled over it with enough pressure to ensure good adhesion. To remove any excess gel medium that may seep out the sides, a damp cloth is employed. Wax paper and heavy books are placed on top to further assist in the adhesion process. The substrate is left to cure for approximately 72 hours. For large, heavy metal substrates, alternative gluing methods should be explored.

5 Toning the Textured Ground and Accent

The metallic ground is painted with Naphthol Red acrylic gesso, using a painting knife to drag the paint into the crevices so the peaks remain silver. The brass metal accent is dry-brushed with the same color using a fan brush. Once the colored gesso has fully cured, waterproof black ink is applied with a brush on top of both surfaces. It is immediately wiped away with paper towels in a circular motion so the ink remains in the crevices.

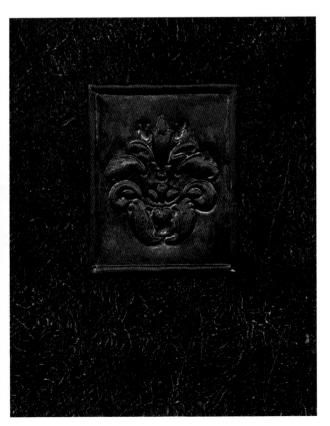

6 Adhering the Custom Accent to the Ground

The back of the embossed metal accent is filled in with modeling paste. Once dry, the accent is applied to the toned and textured ground using acrylic gel medium. The multidimensional, metal-based surface can be further manipulated using mixed-media applications such as collage, drawing, painting or even etching.

experimenting with foam substrates

Unorthodox substrates such as polystyrene foam provide a lightweight, rigid working ground that can be easily carved and manipulated, allowing the picture to penetrate into the third dimension in inventive ways.

materials

Polystyrene foam (2 pieces): 96" × 24" (244cm × 61cm), 1- and 2-inches thick (25mm and 51mm)

FoamCoat
Acrylic paint: gold
Acrylic matte gel medium
White gesso
Waterproof black ink
Conté transfer sheet: brown
Fine tip ballpoint pen

Flat and round brushes
Paint roller
Craft knife
Sponge
Plastic wrap
Wooden stick: sharp at tip
Metal ruler
Table saw
Router with decorative bits
Upholstery tacks
Gold nails
Decorative dresser handle
Cotton cloth
Pastry spatula

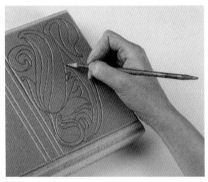

1 Cutting the Panels

Using a table saw, 2-inch (51mm) polystyrene foam is trimmed to size for the top and bottom base panels. Three accent panels of 1-inch (25mm) polystyrene foam are also cut. To play up the architecture of the multidimensional substrate, a router with two different ornamental bits is used to cut decorative edges around the panels.

2 Etching the Surface

A floral design is transferred to the working surface using a brown Conté transfer sheet and a fine-tip ballpoint pen. To etch the inlay design, a craft knife and metal ruler are used. A wooden stick with a blunt, soft tip is employed to open up and round out the cuts. A wooden stick is also used to etch the floral design into the surface. Two passes are made to deepen the etched surface. Note: A transfer sheet can be made by rubbing brown Conté onto layout paper and blending it smooth with a cotton cloth.

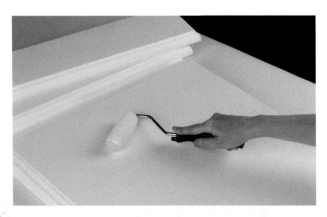

3 Sealing, Priming and Painting the Surfaces

To seal the panels, several coats of FoamCoat are applied. White gesso is applied with a paint roller to prime the surfaces. A brush is employed to get into the crevices. Two coats of waterproof black ink are later applied to each panel with a roller. All sides, including the back, are sealed with FoamCoat, primed with white gesso and painted with black ink.

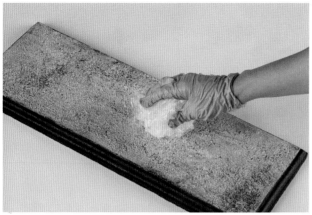

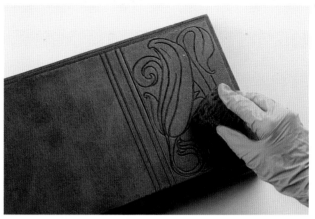

4 Debossing the Surface

Acrylic matte gel medium is applied to the surface of each accent panel using a pastry spatula and a soft flat brush to distribute the medium. To deboss the surface, wadded plastic wrap is used in a blotting fashion.

5 Applying a Gold Patina

Once the gel medium is fully cured, gold acrylic paint is applied to the surfaces in a circular motion using a sponge. The decorative edges of each panel are covered as well.

6 Adding Metal Accents

The accent panels and the bottom panel are adhered to the central base using acrylic matte gel medium. Gold nails and upholstery tacks are coated on the base with the same medium and are inserted into the foam as embellishments. A dresser handle is also introduced into the mix, using the gel medium as an adhesive.

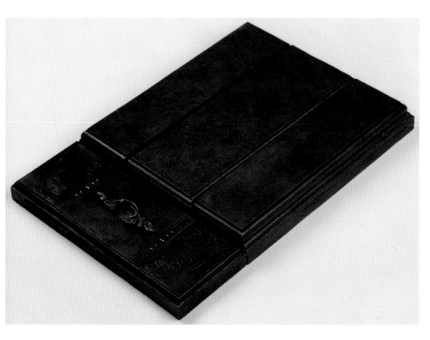

7 Finished Custom Surface

The multidimensional working ground is ready to be further developed, possibly introducing a subject into the three-paneled composition.

using layered panels with mixed surfaces

materials

Oak board ¾-inch (19mm) thick
Masonite ¼-inch (6mm) thick
Poplar wood strips ¾" (19mm) thick × 1½"
 (38mm) wide
Acrylic-primed linen canvas

White gesso
Bookbinder's glue: pH neutral PVA
Isopropyl alcohol
Wood glue
Wood filler

Sponge brush
Flat bristle brush
Painting knife
Brayer
Screws
Sandpaper
Wax paper
Heavy books
Drill

Multilayered grounds with different surface textures create a provocative topography that can be seen from a multitude of angles, adding not only depth and dimension but also further meaning to the work.

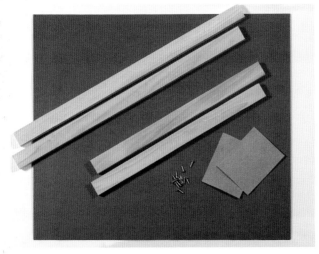

1 Building the Base
A base ground is constructed using Masonite for the top and poplar wood strips for the framework. Both wood glue and screws help to secure the support. The Masonite panel is cleaned with isopropyl alcohol and sanded on top to allow a primer to adhere to the surface. Wood filler, applied with a painting knife, is used to cover the recessed screws, and sanded smooth once dry.

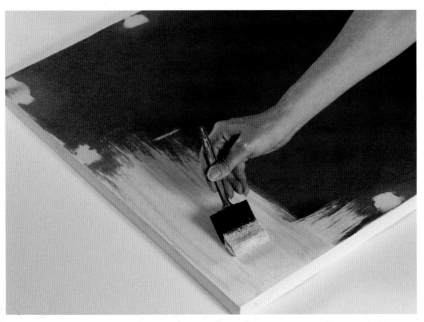

2 Priming the Surface
Several coats of gesso are applied to the surface with a sponge brush and sanded between each coat.

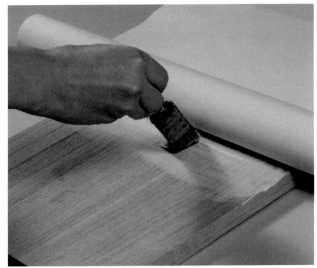

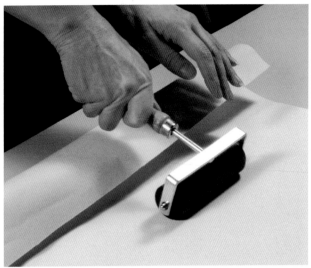

3 Preparing the Accent Panel

An oak panel is cut to size and sanded smooth. Acrylic-primed linen canvas is cut larger than the panel, allowing for the material to wrap around the edges of the board. The canvas is then rolled and placed in the middle of the wood. PVA glue is applied with a flat bristle brush starting with the middle of the panel.

4 Adhering the Canvas

The canvas is unrolled over the glued area and flattened using a brayer. The process is continued until the surface has been fully covered. Wax paper and heavy books are placed on top to help secure the canvas to the panel. Later, the edges are glued and the canvas is wrapped around the back.

5 Layering the Panels

Both the base panel and accent panel are put into position. From the back, holes are drilled and screws are used to permanently secure the panels together.

employing inlaid boxes

Penetrating the picture plane with inlaid boxes, unique enclosures and imaginary windows creates an entirely new, more captivating spatial arrangement. With the addition of custom add-ons such as kinetic, free-moving accents, the multidimensional surface comes alive, making it dynamic and sensory-charged.

materials

Aspen wood ¼" (6mm) thick × 4" (10cm) wide
Masonite ¼" (6mm) thick
Poplar wood strips ¾" (19mm) thick × 1½" (38mm) wide
Acrylic-primed linen canvas

Acrylic paint
Graphite pencil
Modeling paste
Bookbinder's glue: pH neutral PVA
Wood glue

Utility knife
Screws
Nails

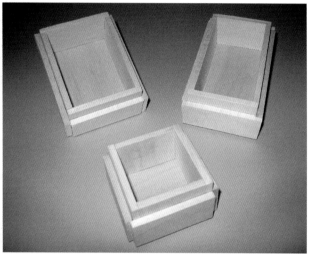

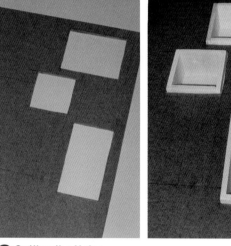

1 Building the Boxes

Three differently sized boxes are constructed using aspen wood, wood glue and small nails. To establish a way to adhere the boxes to the back of the painting ground, poplar wood strips are fastened to the sides of the boxes with wood glue.

2 Cutting the Holes

Masonite is cut to size and marked with a graphite pencil to establish where each box will be located in the composition. The holes are cut using a utility knife. The wooden boxes are temporarily set into position from the back to test the fit. The boxes are then removed and set aside.

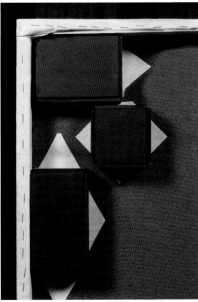

3 Applying the Canvas and Adhering the Boxes

Poplar strips are added as a supportive framework to the back of the Masonite panel using wood glue and screws. Acrylic-primed linen canvas is adhered to the Masonite surface using the same technique as in steps 3 and 4 of the previous demonstration. When dry, the canvas covering the hole areas is cut from the back with a utility knife in an X format. The resulting triangular shapes are wrapped around the back and adhered with PVA glue. The boxes are painted on all sides with acrylic paint and adhered to the panel from the back using wood glue. Modeling paste is used to fill in any gaps.

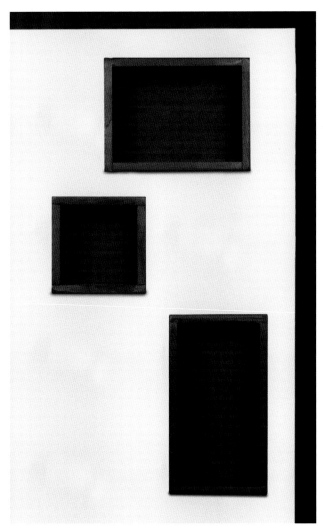

4 Finished Inlaid Boxes

The dimensional panel boasts three inlaid boxes that will house intriguing decorative accents. See the piece *Meditative Pathways* in the beginning of chapter 6 to view the finished application of this demonstration.

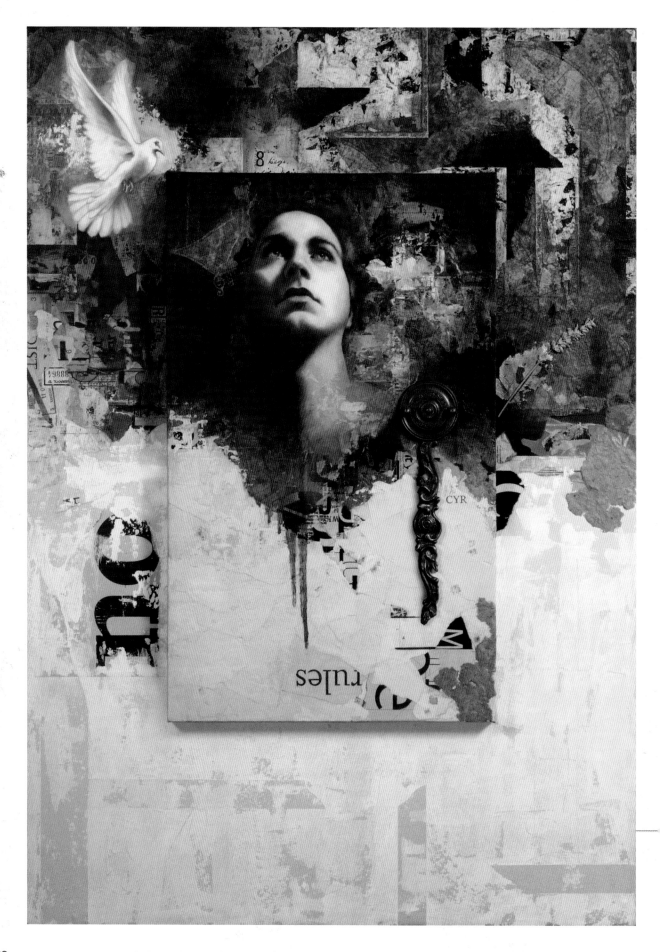

building a tactile environment

Dramatically altering the topography of the working surface transforms the pictorial landscape in extraordinary ways, creating an imaginative environment that is not only multidimensional but also multi-sensory. Building the layers of the painting ground establishes a complex choreography of tactile sensations incredibly abundant with sentience. Once drawing, painting and other mediums are introduced into the mix, the multilayered surface is enlivened with newfound possibilities. Unveiling a world beyond the picture plane, the dimensional landscape takes on a more expansive, symbolic role in the pictorial realm, making a visceral connection with all who encounter its presence.

Creative Matter Painting

To develop a more tactile, sense-based approach to picture making, artists are experimenting with a tantalizing array of natural and synthetic matter and materials, utilizing both traditional and unconventional tools. From plaster, modeling and molding paste, acrylic gel medium, crackle paste, wax, self-leveling and clear tar gel to gesso or resin mixed with crushed marble, pumice, ceramic and glass beads, fibers, sand, saw dust, wood chips, seeds and other aggregates, alternative topographic, bas-relief treatments are being explored.

Once applied to a rigid working surface, custom grounds can be further manipulated with combs, sticks, serrated scrapers, forks and other unconventional mark-making tools that have been repurposed from myriad disciplines. Both additive and subtractive methods are being employed in inventive combinations. There are almost no limitations to what can be done to add texture, depth and dimension to the surface of an artistic working ground.

Incorporating Collage

Collage also offers intriguing effects when it comes to building the visual density and psychological impact of the working surface. Old letters, newspaper clippings, vintage sewing pattern tissue, diary pages, tickets, postmarks, textured and dimensional wallpaper, metallic tape and corrugated cardboard are all finding their way into the mixed-media domain in provocative ways. Taken out of their ordinary context, disparate detritus and found ephemera can be reorganized, overlapped and juxtaposed to create a thought-provoking environment that is sensory-charged. The various pictorial elements take on multiple roles, and the power of suggestion expands the cognitive faculties.

When techniques such as tearing, scoring, die-cutting, punching, wrinkling, creasing, burning, stitching, weaving, embossing and debossing are employed to handmade, custom-treated and machine-made papers and ephemera, the surface becomes quite evocative. With every layer, the multidimensional working ground establishes a demeanor that speaks to the onlooker in a way that not only ignites the senses but also challenges the mind to find alternative connections.

Excavating the Surface

Once the layers of the tactile landscape begin to build, excavating back into the multidimensional surface sparks curiosity, encouraging further inspection and even participation in the messaging. Tearing away, scratching into, peeling back or sanding a heavily layered surface with a flat razor knife, fork, rock, sharpened stick or piece of sandpaper can reinvigorate the tactile, dimensional painting ground. By exposing subsequent layers that lie beneath, the excavated work reveals a level of pictorial and psychological depth that expands the limits of representational, narrative interpretation to encompass a more metaphorical approach to picture making.

Challenging Conventional Approaches

By challenging what is possible not only in spatial acrobatics but also in visual communications, artists are expanding the boundaries of visual expression, introducing alternative approaches in handling both form and content. The tactile, multilayered and multidimensional work of art has opened the door for emotionally charged, concept-based works to enter into the culture, penetrating the social consciousness with a fresh perspective.

Building the layers of the painting ground establishes a complex choreography of tactile sensations incredibly abundant with sentience. Once drawing, painting and other mediums are introduced into the mix, the multilayered surface is enlivened with newfound possibilities.

Title: Self Awareness
Size: 30¼" × 21¼" × 2 ⅜" (77cm × 54cm × 6cm)
Mediums: acrylic, oil, ink and graphite
Materials: textured paper, tissue, ephemera, dried flower, gold painted leaf, decorative metal accents and metal button
Techniques: collage, assemblage, dripping, sanding, scraping, peeling back, painting knife, tape resist and type transfer
Surfaces: linen canvas over Masonite and board with wooden framework

Once the layers of the tactile landscape begin to build, excavating back into the multi-dimensional surface sparks curiosity, encouraging further inspection and even participation in the messaging.

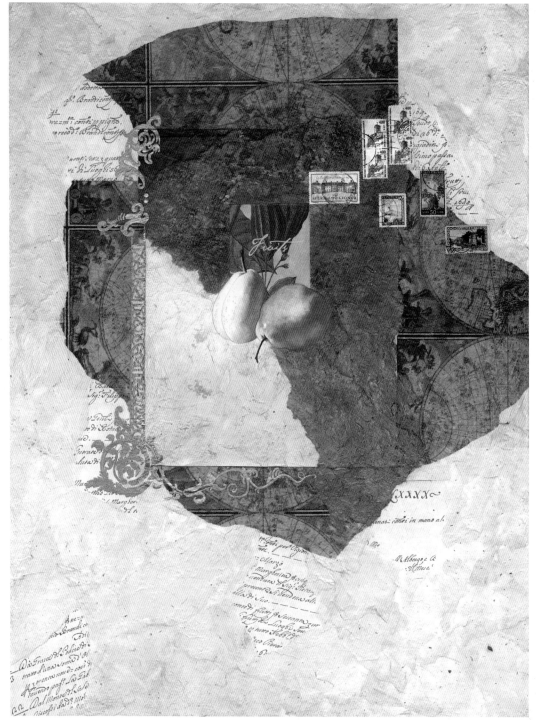

Title: Pears
Size: 24" × 18" × 1¾" (61cm × 46cm × 4cm)
Mediums: oil and acrylic
Materials: handmade paper, ephemera and vintage stamps
Techniques: collage, tearing and peeling
Surfaces: linen canvas over Masonite with wooden framework

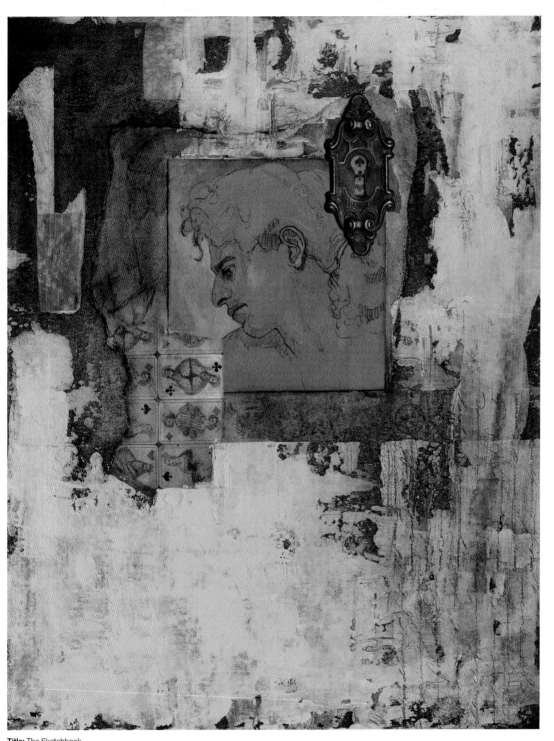

Title: The Sketchbook
Size: 14" × 11" (36cm × 28cm)
Mediums: graphite, ink, acrylic and oil
Materials: textured paper, ephemera and decorative metal accent
Techniques: collage, assemblage, scraping, peeling back, knife application, tape resist and oil rub-off
Surfaces: colored charcoal paper and illustration board

paper treatments and finishes

Both hand- and machine-made papers feature a variety of weights, thicknesses, absorbencies, finishes and colors, yielding an enticing array of creative possibilities for artists to explore. When custom treatments and finishes are employed, paper is transformed into a versatile, visually expressive working surface.

Tearing, Peeling and Burning

To establish a distinctive edge or border, lightweight- and heavy-ply papers and boards can be creatively manipulated by ripping, peeling back the layers and burning the edges. When it comes to tearing and peeling, freehand approaches allow for an organic, irregular look and feel, while a controlled approach using a straightedge yields a more defined, rigid result. I find that slowly peeling the paper forward creates a multilayered edge while peeling back the paper in the opposite direction establishes a more deckled appearance. Each technique offers a variety of creative applications.

For an out-of-the-ordinary border treatment, burning the edges of paper can offer surprising results. I like to dampen the surface first before passing it over a lit candle, as it allows for a bit more control. To protect a very fragile piece of previously burned paper, the surface needs to be sprayed several times on both sides with acrylic fixative once it has cooled. A few coats of acrylic matte medium can then be carefully applied to both sides with a soft brush, further sealing and preparing the surface for collage or painting.

Scoring, Cutting and Punching

To push the flat paper surface into the third dimension, scoring, cutting, punching or drilling into heavy card stocks, paper boards or laminated duplexes and removing the various layers can provide an engaging array of architectural possibilities. If the surface of heavy paper or illustration board is built up with collage, a primer, heavy medium, paste or paint, the density will be even more apparent once the excavating process takes place. Another great way to add dimension is to bevel the edges of a paperboard with an angled mat cutter, allowing the side plane to be more actively

involved in the reading of a piece. Numerous constructive options are just waiting to be explored.

To further penetrate the paper surface, custom and commercially available stencil cutters, corner die-cutters, hole punchers, bindery punchers, pinking shears, decorative scissors, awls, sewing needles and a variety of other handheld tools are being used in myriad ways. In addition, old mechanical processes from bygone eras are also being employed to alter the topography of the two-dimensional surface. Antique passport punchers and vintage stamp perforators are just a few of the processes being introduced into paper-based works. When I'm making a collage-infused understructure for my mixed-media paintings, I often like to score, cut and punch into the surface of the various papers and ephemera that I use. It not only changes the topographical landscape but also alters the way paint interacts with the surface, creating a lusciously dense, visually dynamic environment in which to work.

Embossing and Debossing

Embossing or debossing the surface also offers exquisitely tactile, bas-relief effects. To emboss paper, a light table, an embossing stylus and a template or stencil are all that is needed. The template is placed underneath the paper while gentle rubbing with a stylus is done to reveal a raised surface on the opposing side. To maintain the embossed shape during collage applications, it is important to fill the backside with molding paste or something similar. When dry, the embossed paper can be permanently adhered to any surface and will retain its shape. Dimensional stenciling, using modeling, molding or stencil paste and a template, as well as thermal embossing, using ink, embossing powder and a heat gun, also provides an enticing range of creative possibilities when it comes to introducing raised accents into mixed-media works.

For debossing the paper surface, collagraph printing exhibits seemingly endless topographic options to exploit, where ink aids in revealing a multidimensional, highly textural design. A custom plate can be made by adhering bas-relief, natural and man-made materials and objects with PVA glue or gel medium to a rigid

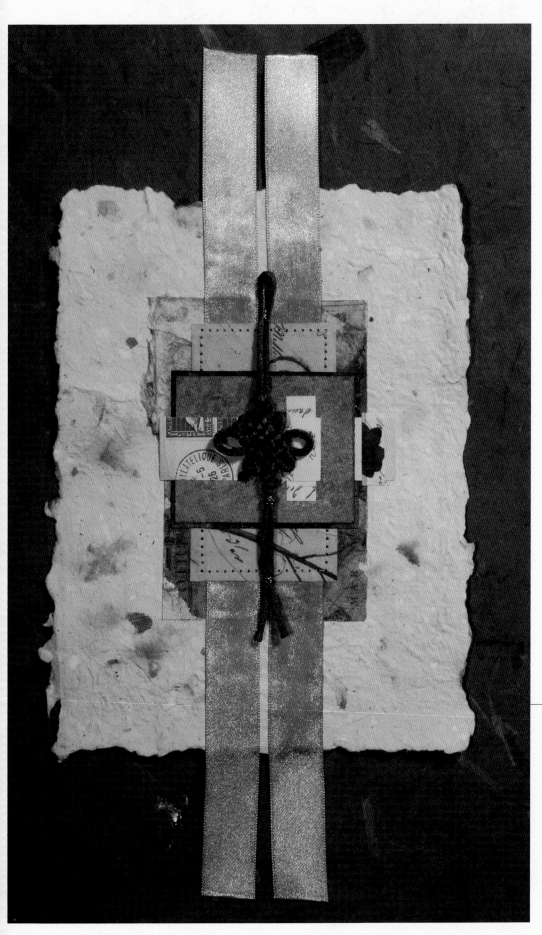

Handmade, printed and custom-treated papers are ripped, cut and woven into each other as well as into gold ribbon. PVA glue is used to secure the various pieces in position. Machine stitching is added as a border accent. A Chinese pan chang knot, symbolic of the endless cycle of nature, is created using red rope that has been sponged with metallic acrylic paint and wrapped with copper wire in key areas.

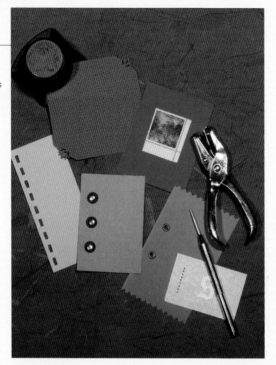

These papers have been die-cut, perforated and punched with a variety of tools. Eyelets and brads are introduced as dimensional accents.

substrate. Once everything is dry, the surface should be completely sealed with gesso and acrylic matte medium to allow the plate to be washed and reused. For printing, the dimensional plate can be inked with a flat scraper tool, brayer or brush. I like to also employ an etching tarlatan, rubbing the ink into the crevices of the plate for a greater range of detail. When printing, it is best to use heavyweight printmaking paper that has been stretched and is still slightly damp.

Weaving, Stitching and Embellishing

To further explore hybrid approaches, artists are taking inspiration from myriad disciplines. When it comes to alternative approaches in the manipulation of paper, the fashion, fiber arts and textile industries can offer insight, as cloth is, in many ways, quite similar. Techniques such as weaving, quilting and stitching offer derivative possibilities when it comes to the design, manipulation and adhering of paper to a surface,

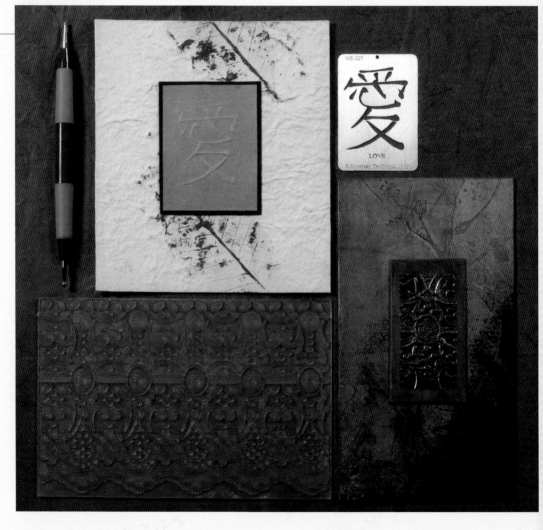

Handmade paper infused with skeleton leaves is sponged with copper acrylic paint, and an embossed paper tip-in, mounted onto black board, is adhered on top as an accent. Printmaking paper is debossed and inked using a custom collagraphic plate. Heavy-duty aluminum foil, debossed with a plastic template and a soft brush, is applied on top of beveled illustration board that has been painted with bronze acrylic paint.

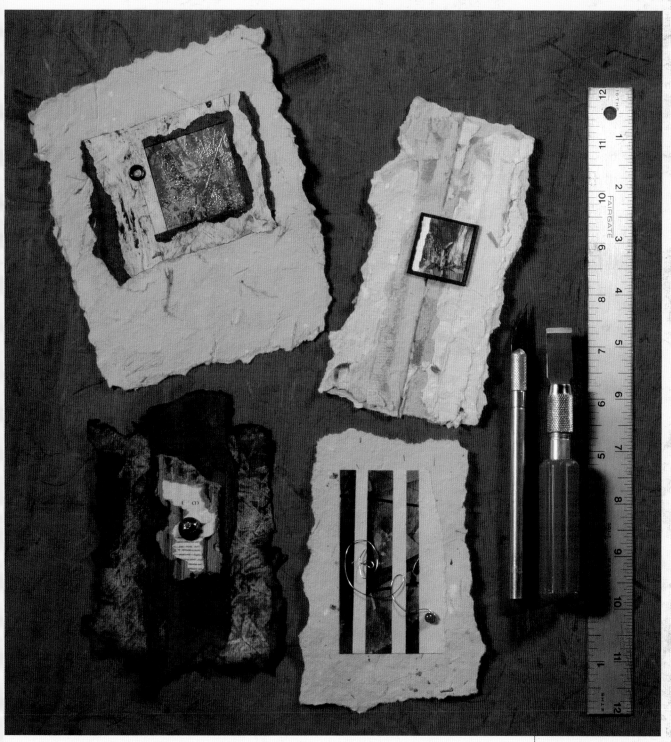

while knitting, crocheting, embroidery and macramé introduce an array of embellishment and accent ideas. I love to adorn the painted surface with eyelets, grommets, brads, buttons, beads, knotting, wire and other small-scale add-ons as the finishing touches that add personality and character. I find that the minutest details can often make the biggest impact.

To continue to discover new methods, it is important to experiment with tools, materials and techniques from other disciplines. Crosspollination is key to establishing a robust exchange, introducing alternative approaches into the collage and mixed-media continuum.

using xerography and laser printing

Aesthetic play with a copy machine and laser printer can yield intriguing results. Overlapping, creasing, crinkling, ripping, enlarging or reducing over several generations of copies can alter the original content in a dynamic way, creating a unique, more graphic composition.

materials

Illustration board: 4-ply
Clear transparency film
White bond paper
Tracing paper

Powdered graphite
Graphite pencils
Graphite transfer sheet
Fine ballpoint pen
Technical pen with black ink
Colored pencils: warm and cool gray
Payne's Gray oil paint
Mineral spirits
Acrylic matte medium
Bookbinder's glue: pH neutral PVA
Vellum spray fixative

Craft knife
Large bristle brush
Flat nylon brush
Brayer
Blending stumps
Kneaded eraser
Adjustable eraser
Cotton swabs
Metal straightedge ruler
Copy machine
Laser printer
Wax paper
Cotton cloth

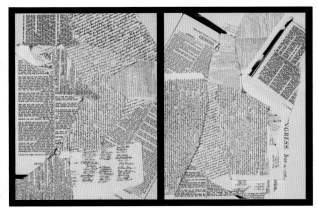

1 Playing With Composition

Using a copy machine to enlarge and reduce, several prints are made of famous historical documents available in the public domain, such as the Bible and the Declaration of Independence. Each is ripped to create unique edges and the pieces are arranged to form several compositions. Additional decorative type is set on the computer and a laser print is made on clear transparency film. The transparency is moved around to determine placement for the final composition.

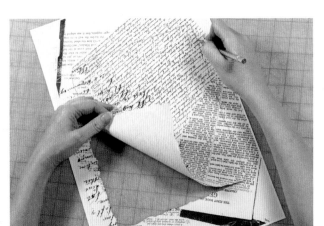

2 Establishing a Unique Border

The various pieces of ripped paper and the clear transparency film are placed on a photocopy machine face down and a new copy is made. Using a craft knife, the composition is cut so that the outer edge of the piece resembles an old writing tablet.

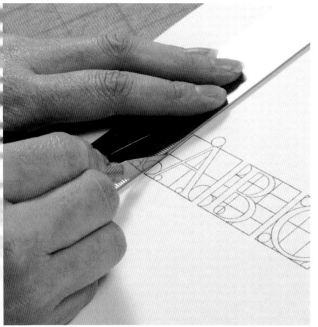

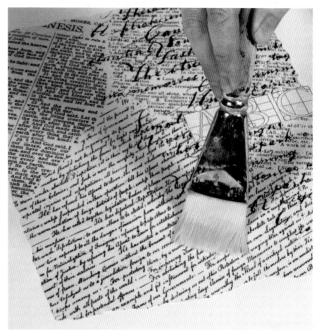

3 Creating an Accent
A typographic accent is created and printed out using a black-and-white laser printer. The edges are trimmed using a craft knife and a metal straightedge.

4 Mounting to Board
Using PVA glue and a flat nylon brush, the base art and typographic accent are adhered to illustration board. Wax paper is placed on top and a brayer is used to eliminate any air bubbles. Once dry, several coats of acrylic matte medium are brushed on top to seal the surface.

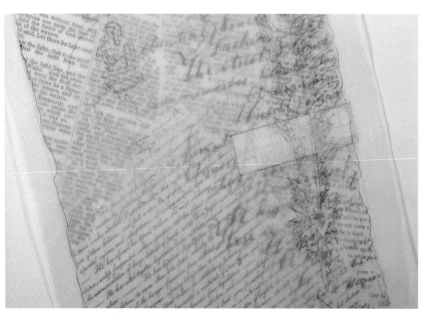

5 Adding the Subject
A line drawing is created on tracing paper, which allows the graphic background to show through. The subject is positioned so the subject and the background work in harmony. The line drawing is transferred to the working surface using a graphite transfer sheet and a ballpoint pen. Note: A graphite transfer sheet can be created by rubbing graphite onto layout paper, using mineral spirits on a cotton cloth to spread the medium.

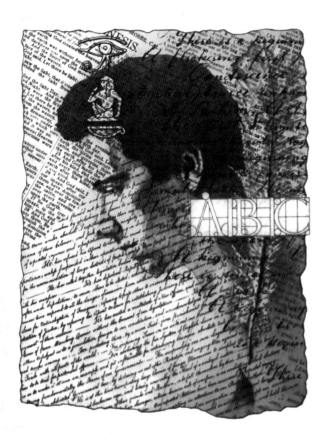

6 Establishing the Values

The main subject is established in powdered graphite, pencils and blending stumps. Ink and a technical pen are used to add the hieroglyphics. When the drawing is complete, vellum spray fixative is applied to seal the surface. Always use protective gear and spray in a well-ventilated area.

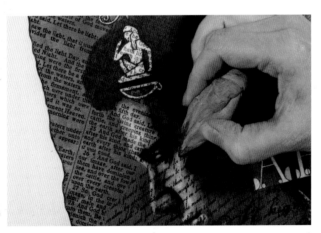

7 Creating the Mood

Using mineral spirits in a well ventilated area, Payne's Gray oil paint and a large bristle brush, a wash is applied to the entire surface. Once dry, light areas are lifted using cotton swabs, a kneaded eraser and a sharpened adjustable eraser. When the lift-out is completed, vellum spray fixative is employed to seal the surface.

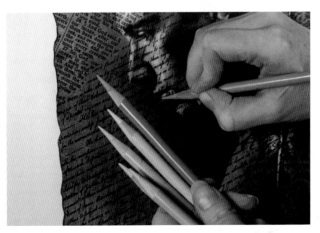

8 Employing Warm and Cool Tones

Various warm and cool gray colored pencils are used throughout to enhance the transitions as well as add visual interest through temperature changes.

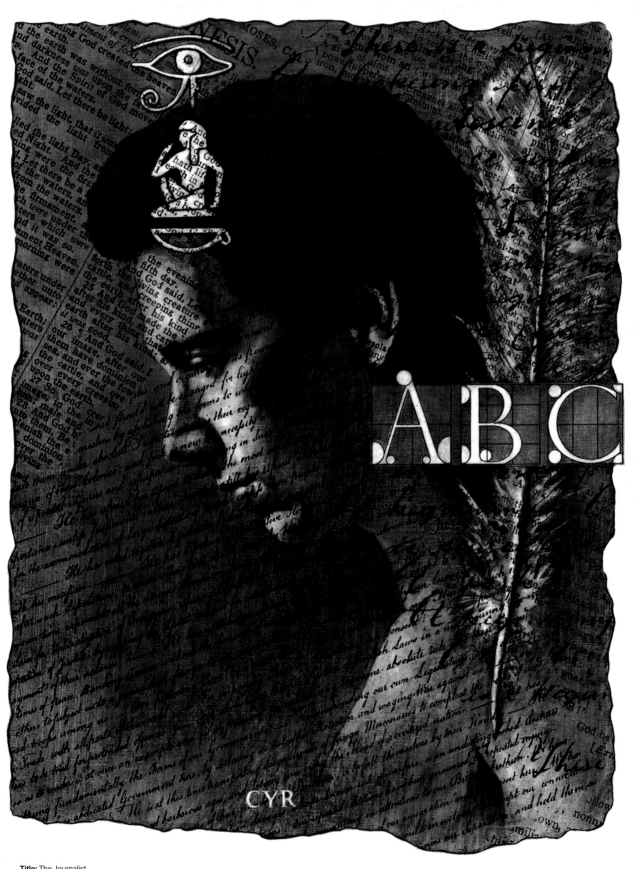

Title: The Journalist
Size: 11" × 8½" (28cm × 22cm)
Mediums: mixed media
Surface: illustration board
Collection: Museum of American Illustration, NYC

employing additive and subtractive processes

By infusing the working surface with additive processes such as textural painting and collage, and subtractive process like scratching, sanding and peeling back the layers, a visually compelling image that ignites both the mind and the senses begins to unfold.

materials

Masonite ¼-ich (6mm) thick
Poplar wood strips ¾" × 1½" (19mm × 38mm)
Papers: various
Ephemera
Silver tape: water-resistant
Rub-on lettering

Bookbinder's glue: pH neutral PVA
White gesso
Acrylic matte gel medium
Acrylic matte medium
Resin sand texture gel
Acrylic paint
Oil paint
Liquin
Black ink pad
Graphite powder, technical pencils and leads
Vellum fixative

Blending stumps
Painting knife
Painter's tape
Paint roller
Sponges: organic and synthetic
Wooden stick: sharp at tip
Round, flat and bright brushes
Straight-edge knife
Craft knife
Brayer
Embossing stylus
Rubber stamp
Sandpaper and sanding block
Hole punchers: large and small
Wax paper
Screws
Drill

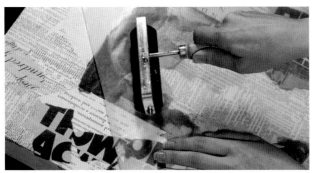

1 Applying a Collage

A dimensional ground, built from Masonite and poplar wood strips, is layered with various ephemera and papers that have been printed, punched, cut and ripped. PVA glue is used to adhere the papers to the working surface. Wax paper is placed on top and a brayer is used to eliminate any air bubbles. Rub-on letters and numerals in various sizes and colors are applied to the surface with a embossing stylus. The collage layer symbolizes the chaotic onslaught of messages experienced by mankind.

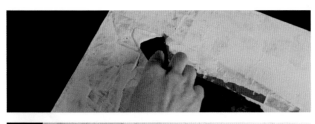

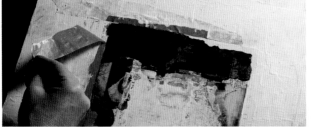

2 Employing a Resist

Gesso is applied to the working surface using a painting knife, almost completely covering the text of the collage layer below. Painter's tape is then employed as a resist. It is placed in the upper-left corner in a crosslike design. Another layer of gesso is applied over the tape and to all other surface areas except the interior box, which will house the figurative subject. Once dry, the tape is removed to reveal an inlaid design.

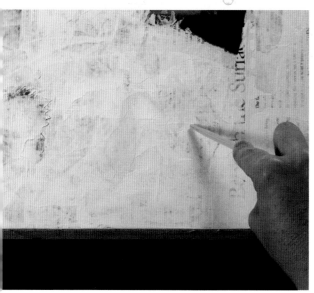

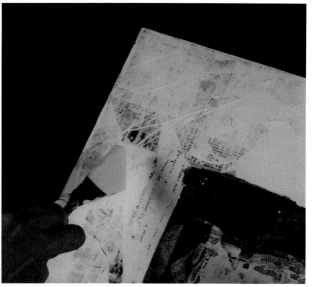

3 Scratching In
Before the second coat of gesso is dry, a sharpened wooden stick is used to scratch into the wet surface. This will give the painted ground yet another debossed effect.

4 Dripping
Gesso is applied to the surface by dripping it from the end of a painting knife. The piece is left to dry overnight until it is fully cured. Speeding the drying process with a hairdryer may cause cracking, as the gesso's surface will dry faster than the interior.

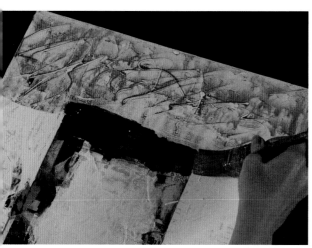

5 Applying a Warm Undertone
Burnt Sienna acrylic paint, thinned with water, is applied with a brush and allowed to drip down the composition. Several coats are applied.

6 Peeling Back
Areas of the collage are cut into and torn off with a straight-edged knife. To further distress the surface, sandpaper and a sanding block are used throughout the composition. Acrylic matte medium is applied to seal the surface. Exposing the under layers represents leaving one's earthly existence behind.

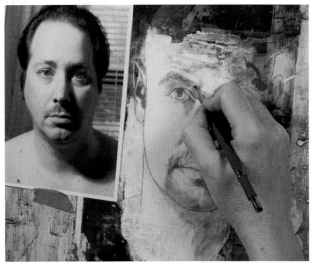

7 Drawing the Subject

The main subject is added to the composition using powdered graphite, technical pencils with various graphite leads, brushes and blending stumps. Although a photo reference is employed, the features are altered to convey the desired character. Vellum spray fixative is used to seal the surface. Always use protective gear and spray in a well ventilated area.

8 Creating Faux Metal

Water-resistant silver tape is embossed, cut, punched and layered onto the working surface to suggest a corroded metal shield. A sharpened wooden stick is used to deboss the tape with circular and linear marks. Several hole punchers are also employed to deboss and punch into the surface. In key areas, gesso is built up in layers and painted in acrylic to resemble small bolts. Screws that have been abraded with sandpaper and then painted with acrylic paint are inserted into holes that have been drilled into the surface of the panel. Acrylic gel medium and resin sand texture gel are applied to the metallic surface with a painting knife, using a higher concentration in the corner areas to create the look of erosion. Payne's Gray and Burnt Sienna acrylic paint are applied on top and then wiped away with a rag to accentuate the crevices and holes. Type is introduced using a rubber stamp and black ink.

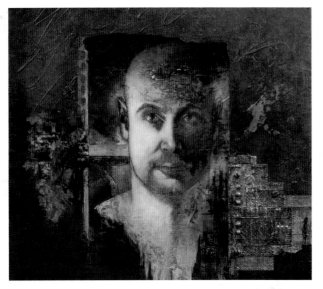

9 Establishing the Mood

Both the subject and the industrial environment in the background are blocked in using acrylics, a paint roller, brushes, sponges and a painting knife. The sides of the piece are also painted. Acrylic matte medium is used to seal the entire surface. Finishing touches are executed in oil using Liquin as the medium. The finished painting deals with man's journey from this life to the next.

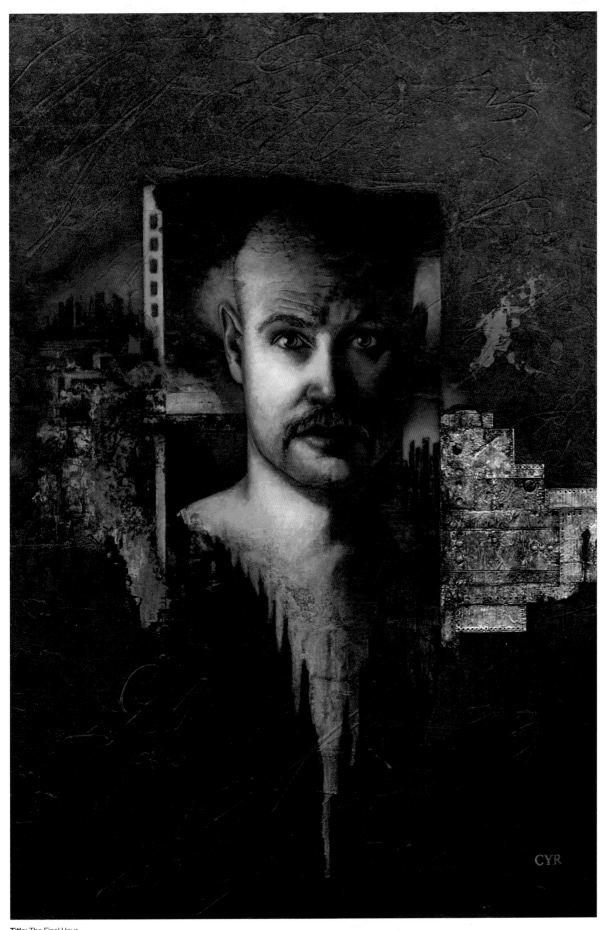

Title: The Final Hour
Size: 24" × 18" (61cm × 46cm)
Mediums: mixed media
Surfaces: Masonite with wooden framework

symbolism, metaphor and allegory

"As the sun sets over the horizon, the battle between good and evil commences to engage forces. Through the entangled fight, the restless warrior becomes fearful and anxious of the unknown. In the mirage, the heart grows weary, the breath becomes shallow and all seems bleak. With nothing of this earth to rely on, the soul looks inward in search of higher ground. The merciful Creator speaks and a glimmer of hope shines like the dawn of a new day. Full of hope and opportunity to begin anew, the faithful warrior presses on, and a newfound sense of strength ensues."

Much of my work has a spiritual, mythological or psychological relevance where metaphors, symbolism and allegory are used to stimulate curiosity, provoke thought and encourage further inspection. Throughout my pictorial idiom, I employ a concept-based, message-driven approach, evoking the imagination and the senses. I want the onlooker to be intellectually engaged with an instinctual desire to look deeper into the work to discover hidden messages within the layers of symbolic meaning.

The mixed-media painting entitled *Masquerade of Wits* is a conceptual portrait about the inner struggle to find clarity in a world full of uncertainty, distractions and temptation. In the piece, a contemplative female figure is presented as a symbolic warrior who metaphorically fights against the forces that create despair, anxiety and fear in her life. The meditative subject looks inward through a symbolic mask. A physical manifestation of her internal psyche, the mask dissolves into the flesh to become one with the myriad levels of consciousness present in the mind's eye. Like a protective shield, the apparitional, mask-like form displays imagery from ancient armor and military attire, reminiscent of a time when the righteous always triumphed over the malevolent forces of evil. Olive branches, historically emblematic of peace, are introduced in the brass assemblage accent as

Title: Masquerade of Wits
Size: 23" × 26¾" × 1½" (58cm × 68cm × 4cm)
Medium: mixed media
Surface: Masonite with wooden framework

well as intertwined throughout the war-inspired ico-
nography to create an interesting dichotomy.

Considered windows to the soul, the eyes project a
serene and crystal-clear blue expanding from a flam-
ing orange center. The complementary color scheme
alludes to the setting of the sun, when the light fades
and darkness takes reign, creating a dynamic inter-
play between life's often paradoxical forces. Although
the eyes are astute sensory filters, they are not perfect
interpreters of reality, as perception can often be
misleading. In times of doubt and fear, the malicious
Tempter intervenes, presenting a false reality that
uses trickery to set one off balance. A masquerade of
wits ensues as virtue and truth battle deception and
deceit. The overall design and custom accents are
based upon the sixth chakra. Known spiritually as the
third eye, the Anja chakra represents a mystical gate-
way to the inner realms of higher consciousness. For
insight and enlightenment from the heavens above,
the figure is presented as gazing, looking inward to
evoke the third eye. Through meditation and prayer,
teleportation from the limitations and boundaries of
the external, earth-bound existence to the all-seeing
world of nirvana that exists within is possible. In times
of distress, the divine spirit that is forever omnipresent

helps guide the troubled soul on a path of hope and
lucidity of mind and purpose. The indigo color, deep
violet blue to a dark grayish blue, that is known in the
all-seeing sixth chakra symbol is ever-present through-
out the perimeters of the mixed-media piece. The
perfectly symmetrical balance of the facial features
and mask juxtaposed against the more cacophonic
environment is highly significant, as it conveys the
importance of maintaining one's balance amidst the
chaos of life.

Throughout the highly conceptual piece, the
use of subtle allegory is present. Hidden messages
encourage balance and discourage the manifesta-
tions of fear and doubt that hold one back from the
fullness of what life has to offer. Being human, no one
is perfect but instead intrinsically flawed and prone
to fall, especially in times of despair and internal
turmoil. But with guidance from above, one is able
to regain the strength needed to continue to move
forward from a place of stability. Hope and abound-
ing possibilities present themselves with the break of
every new day. Life is an amazing journey of triumphs
and tribulations, a continuous battle of wits. "Fight the
good fight of faith" (Paul to Timothy I, 6:12), finding a
way out of the dark and into the light. Godspeed.

materials

Masonite: ¼-inch (6mm) thick
Poplar wood strips: ¾" × 1½" (9mm × 38mm)
Bristol board
Printmaking paper
Bond paper: 11" × 17" (28cm × 43cm)
Synthetic mesh
Cheesecloth
Colored tissue paper
Sketchbook
Facial tissue
Transparent plastic sheets
Frisket
Ephemera: various paper weights and textures

Acrylic paint
Acrylic matte medium
Acrylic matte gel medium

Molding paste
White gesso
Oil paint
Liquin
Pigment inks
Powdered graphite and pencils
Ebony pencil
Colored pencils
Bookbinder's glue: pH neutral PVA
Vellum fixative

Round, flat, bright, fan and sponge brushes
Painting knife
Sponge
Sponge roller
Cotton cloth
Cotton swabs

Kneaded eraser
Blending stumps
Sandpaper
Brayer
Painter's tape
Glass
Decorative fabric lace
Floral stencil
Plastic grocery bags
Wax paper
Ink-jet printer
Hole and bindery punchers
Desktop custom die-cutter
Decorative hardware: metal
Screws, washers and bolts
Computer and scanner
Drill

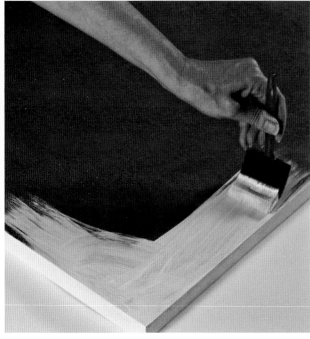

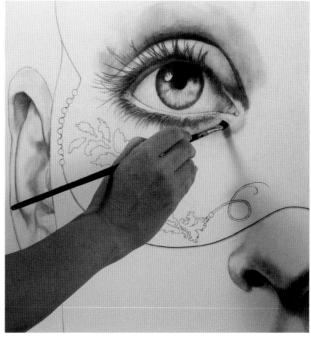

1 Priming the Surface
A dimensional panel made of Masonite and poplar wood strips is primed with several coats of acrylic gesso using a sponge brush. For an even surface, the panel is sanded smooth between each coat. For instructions on building a dimensional substrate, see the step-by-step instructions in chapter 3.

2 Establishing the Values
The main subject is drawn on a primed Masonite surface using graphite pencils. To block in the large areas of tone, powdered graphite and brushes are employed. Blending stumps are used to soften the areas of transition and a kneaded eraser aids in lifting tone when necessary. The area is sprayed with vellum fixative. Always use protective gear and spray in a well-ventilated area.

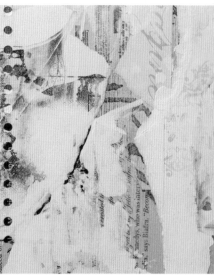

3 Creating the Collage

Printmaking paper, bristol board and various paper ephemera are cut, punched and ripped forward to reveal a layered edge, and backward to show a more deckled edge. The collage pieces are adhered to the surface using PVA glue and a brush. Wax paper is placed on top and a brayer is used to remove any air bubbles. Using a painting knife, acrylic gesso is applied to the lower sides of the mixed-media piece, adding depth and dimension. Frisket is applied to mask off the facial areas.

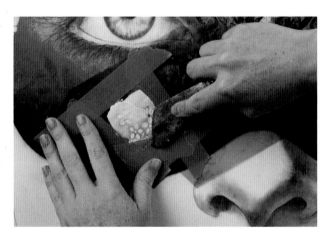
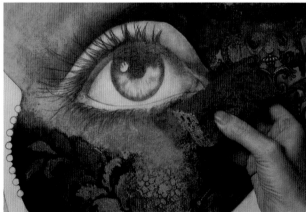

4 Adding Dimensional Stenciling

The mask design is blocked in using brushes and acrylic paint. A floral stencil is taped into position with painter's tape. A raised surface is created using molding paste and a painting knife. Once the embossed design is fully cured, acrylic paint is applied to harmonize the floral areas with the rest of the composition.

5 Sponging

The mask area is further developed using acrylic paints. A sponge is used to add texture and visual interest.

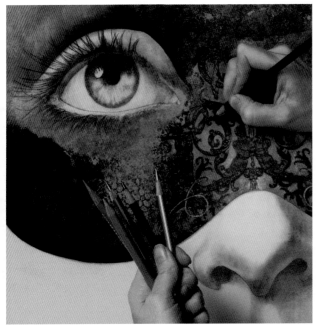

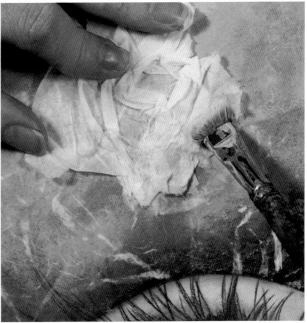

6 Drawing the Details

Using colored pencils, an ebony pencil and acrylic paint, details of the mask and surrounding areas are further developed. The area is sprayed with vellum fixative. Always use protective gear and spray in a well-ventilated area.

7 Adding Tissue Collage

Acrylic matte medium is applied to the working surface and one-ply facial tissue is adhered. Once dry, several coats of matte medium are applied on top as a sealant. When completely cured, the textured area above the eyes is sanded slightly to prepare for the addition of the military iconography that is drawn on top in graphite.

8 Creating Custom-Printed Paper

Line drawings of ancient military attire from the sketchbook are scanned into the computer, altered and composed into an abstract arrangement. Colored tissue paper is taped on a sheet of 11" × 17" (28cm × 43cm) bond paper using painter's tape. The sheet is run through the flat paper path of an ink-jet printer, and the line art composition is imprinted onto the surface using pigment inks. Once dry, the sheet is sprayed vellum fixative. Acrylic matte medium and a brush are used to adhere the tissue paper to the working surface in a folded fashion. Matte medium is also applied to further seal the surface.

9 Blotting

Acrylic is applied throughout the piece with a brush, painting knife and sponge. To create interesting transitions, crinkled plastic grocery bags are used to blot the wet surface, infusing it with an organic pattern.

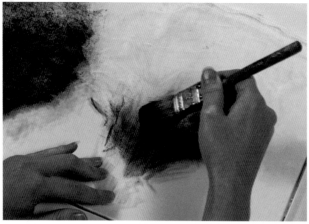

10 Incorporating Cloth and Synthetic Mesh

Synthetic mesh and cheesecloth are painted with acrylic on glass and left to dry. They are later ripped into pieces and applied to the perimeters of the composition using acrylic gel medium.

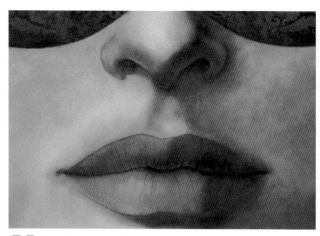

11 Blocking in the Tones

The facial features are blocked in with acrylic washes. Light areas are wiped out using a cotton cloth and cotton swabs to establish a chiaroscuro effect.

12 Employing a Patina

Acrylic matte gel medium is applied with a sponge roller to the mask area and decorative fabric lace is debossed into the surface in an overlapping fashion, creating a distressed texture. Once this is fully cured, gold and copper acrylic paint are drybrushed on top with a fan brush. To highlight the military iconography underneath, pewter and gold acrylic are painted in the areas of light while bronze and antique copper are used for the darks.

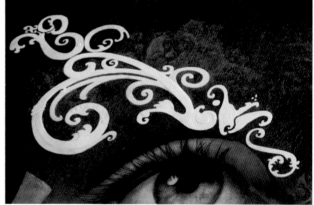

13 Creating Multilayered Accents

Decorative accents are designed on paper, scanned into the computer and die cut into layers on plastic sheets using a miniature die-cutting machine that can accommodate custom designs. Employing a painting knife and molding paste, each stencil layer requires three to four applications to build the surface. Ample time for drying and sanding is allowed between each layer. Matte medium is used to seal the surface before a decorative patina is sponged on with acrylic paint.

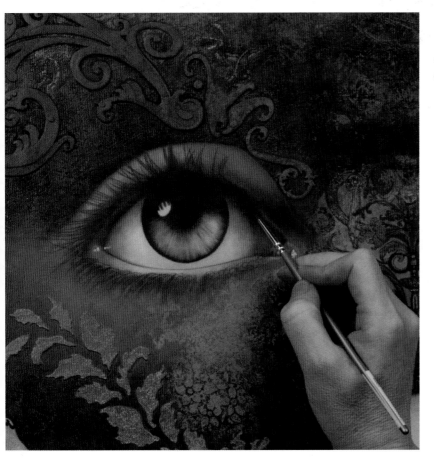

14 Painting the Details
Oil paint is used to render the finer details on the subject. Liquin is employed as the oil painting medium.

15 Customizing Assemblage Accents
Rounded screws are sanded at the top, filled with molding paste, treated with layers of gesso and painted with acrylic paint. The upper central assemblage accent is sponged with gold, copper and bronze acrylic. Holes are drilled through the substrate and the decorative accents are attached to the composition with the custom screws, which are held in place with washers and nuts in the back.

transforming
the surface

When rich transitions and lushly painted passages flow dynamically across the surface of the working ground, the visual landscape is transformed with abounding possibilities. A wondrous environment presents the subconscious mind to the conscious spirit in unexpected and imaginative ways.

Freeing the Mind

To ignite the process, artists are utilizing pure psychic automatism and unconventional, mixed-media painting techniques as catalysts, guiding them on an unchartered journey where the painting seems to take on a life of its own. Once the stream-of-consciousness process begins, the artist relies purely on intuition, beckoning the improvisational spirit within. Throwing caution to the wind, a serendipitous performance commences and all is left to chance. Playful and carefree, the picture evolves with reckless abandonment of the critic that lies dormant in its creator. As the artist moves lyrically across the pictorial surface, happy accidents begin to happen and the intuitively painted environment becomes an adventurous playground for aesthetic exploration and discovery. When one is free from inhibitions and preset expectations, the door opens for that spark of brilliance and magic to come through. Spontaneously and without effort a highly imaginative world known only to the artist begins to reveal itself.

Engaging the Senses

To enhance the experience, artists are utilizing various stimuli. Whether it is conjuring up past experiences or dreams, recalling a thought-provoking book or poem, listening to music or even capturing the sounds, sights or smells of nature, taking in sensory input can act as a springboard to internal emotions and feelings, triggering innate responses onto the painted surface. Without overt concerns for stylistic interpretation, the artist's unique experience naturally comes through in the way the hand translates the cognitive content onto the surface. The pacing, movement, sequence and weight of application are all drawn from the emotional connection established at the commencement of the visceral process. Expressive, meaningful mark-making triggered by a sensory response creates a dynamic, visually compelling environment in which to evolve a more realized subject. As a point of departure, freeform painting establishes a pathway to the subconscious where fantastic landscapes and dreamlike images begin to emerge onto the surface, inspiring imaginative, thought-provoking works.

Pursuing Alternative Methodologies

To keep their process fresh, artists are exploring alternative mixed-media painting techniques, utilizing a range of unconventional tools and materials. Sponging, spattering, stippling, dripping, rolling, spraying, blowing, imprinting, stamping and rubbing are just some of the techniques invigorating the painting ground, infusing it with color, line, shape and pattern. Once the surface begins to build, more subtractive approaches—such as resists, blotting, lifting and dissolving—are being employed with distinctive results. With sealants and fixatives, artists can seamlessly alternate mediums with opposing properties within the same work. In addition, advances in pigments, binders, mediums, additives, flow aids, extenders, retarders and ink-jet receptive coatings have opened the floodgates to a range of possibilities for artists to ponder and play with.

The ongoing exploration of alternative methodologies and approaches in painting has created a dynamic pictorial syntax. No longer is rigidity in process or media the norm. An expansive mindset is at the forefront, and a more aesthetically diverse pictorial idiom is being introduced into the visual vanguard.

Whether it is conjuring up past experiences or dreams, recalling a thought-provoking book or poem, listening to music or even capturing the sounds, sights or smells of nature, taking in sensory input can act as a springboard to internal emotions and feelings, triggering innate responses onto the painted surface.

Title: Performance
Size: 15¾" × 11½" (40cm × 29cm)
Mediums: acrylic and oil
Materials: tissue paper and ephemera
Techniques: dripping and collage
Surface: illustration board

Title: African Dreamer
Size: 10¾" × 14¾" (27cm × 37cm)
Mediums: acrylic, ink, gel medium and oil
Techniques: painting knife, spattering, dripping, blotting, sponging, dissolving, monoprinting, dry-brushing and debossing
Surface: bristol board

When one is free from inhibitions and preset expectations, the door opens for that spark of brilliance and magic to come through. Spontaneously and without effort, a highly imaginative world known only to the artist begins to reveal itself.

Title: The Power of Insight
Size: 16¼" × 8¾" (41cm × 22cm)
Mediums: acrylic, oil, gel medium and modeling paste
Materials: tissue paper and ephemera
Techniques: painting knife, sanding and collage
Surface: canvas mounted on illustration board

resists, blotting, lifting and dissolving

As a way to alter and transform painted passages and transitions, artists are employing resist, blotting, lifting and dissolving techniques in intriguing and unexpected ways. Utilizing both traditional and unconventional materials and approaches, a striking array of creative possibilities is igniting the creative spark.

Resists

When incorporating resist techniques, it is important to note that if thick paint applications are used, many of the resist materials could be trapped under the layers, making it hard to remove them later. Ink, watercolor and very fluid washes of acrylic and gouache work best.

For the retention of fine detail, masking fluid can be employed with precise results using a brush. It can also be randomly applied with a painting knife for a more freeform result. To create a distinctive edge, shape or outline, both frisket and masking tape offer creative solutions, especially when they are torn, cut or punched. Once the desired effect is achieved, the resist can be easily removed. To infuse an area with efflorescent transitions, salt can be sprinkled onto a wet, freshly painted surface, absorbing the water-based media to form crystal-like patterns. The smaller the granules and the higher the concentration of salt, the more texture-infused an area will be and vice versa. It is important to remove the salt completely once the paint has dried. Another technique used to introduce an organic texture into a water-based medium is the employment of ice crystals. By allowing wet, water-based medium to freeze outside, ice forms and begins to crystallize areas. Once inside, the painting can be cleaned and the unique design created by the crystallization can be reworked.

Resists, however, don't always have to be removed. Wax crayons, sticks and pencils—available in a wide assortment of hues—maintain their color and integrity even when many fluidly painted passages are applied on top. Wax-based drawing mediums can be applied by either sketching directly onto the paper surface or by rubbing over an etched or carved, low-relief object that has been placed underneath. The wax marks seamlessly repel the washes of water mediums applied on top, creating an eloquent fusion of both drawn and painted elements.

Blotting

To inject pattern and texture into a freshly painted surface, artists are exploiting the technique of blotting. From paper towels, woven cloth and leaves to plastic grocery bags, bubble wrap, aluminum foil and textured wallpaper, almost every material can be employed flat, altered or in combination. Blotting can also be used to blend paint, establishing interesting transitions between colors.

Over the years, I have experimented with myriad materials when it comes to blotting. I am always on the lookout for new surfaces to manipulate and play with. The hardware store, a fabric retailer, the grocery store or even nature can prove to be valuable resources when it comes to seeking new materials and surfaces. It is important to be sensuously open and aware of one's surroundings, looking for anything that can be repurposed and incorporated into the pictorial realm.

Lifting

When it comes to creatively removing paint, ink or toner from a surface, tape lifting techniques offer provocative results that are uncontrolled and unexpected. When painting, artists are taking advantage of the inherent differences between water- and oil-based mediums. Both acrylic and gouache are being applied over dried oil paint only to remove parts by rubbing or burnishing a piece of clear packing tape over a select area and lifting. Some areas will remain while others will be removed, creating a sense of mystery as to what lies below.

Acrylic gel, gloss or matte mediums can also be used to lift the toner from photocopies or the ink from printed matter. Several layers can be applied to build the durability of the surface. Once the medium is dry, water can be used on the backside to assist in rubbing off the paper so that only the toner or ink remains. Once applied onto a painted substrate, the areas that are colored in the print will be slightly transparent and the

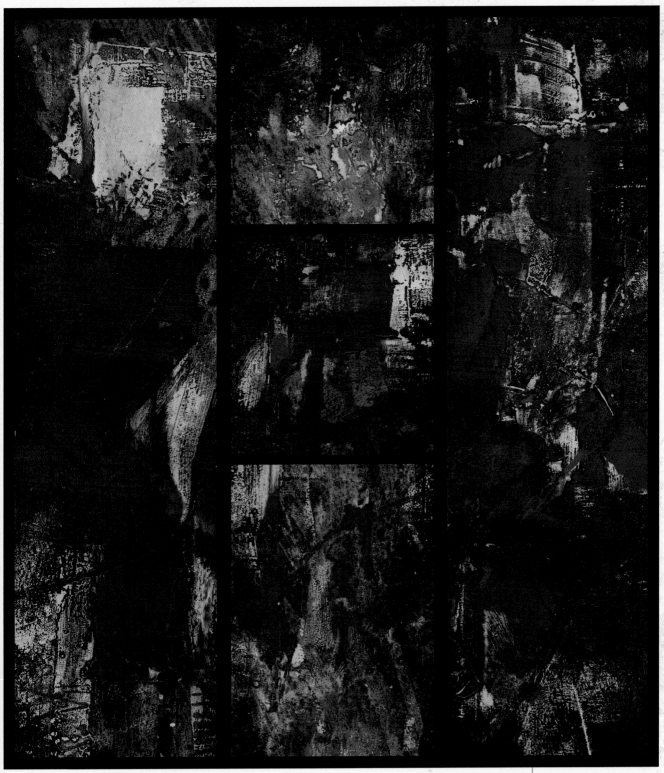

Gouache is applied with a painting knife on top of an oil-painted black base. Clear tape is used to lift the gouache, revealing a distressed abstract series of five images that function as a cohesive work of art.

areas that are white will be clear, allowing the painted environment to show through. Acrylic medium can also assist in permanently adhering the lifted image onto a working surface. I find this technique to be a great way to play with my sketches, journal passages and experimental paintings that have been brought into the computer. Because the lifting process uses copies, the original work remains untouched while many compositional interpretations can be considered. It is a great way to create preliminary studies as a springboard for more finished works.

Dissolving

To create striking transitions that blur the distinction between figure and ground, artists are using dissolve techniques. Dissolving can decompose and alter an image in a way that is organic and unexpected, achieving a distinctive look that could not have been created using straightforward painting means.

When it comes to watercolor, gouache and non-waterproof ink, the application of clear water will reactivate a painted surface. Spraying, dripping and spattering are just some of the techniques being explored. For acrylics, isopropyl alcohol, also called rubbing alcohol, can be used to penetrate areas that have not been fully cured. Oil paintings that employ a solvent as the medium can also take advantage of the dissolve process. Using a large brush and mineral spirits, a wash can be applied to the top of a thinly painted image, letting the streaks run down to create a dramatic look. An old toothbrush can spatter an oil-based work with a solvent, breaking up solid areas in an interesting way. Using solvents over a heavy, thickly painted oil-based image is not recommended, as cracking may occur.

Using wax-based colored pencils, sticks and crayons, layered rubbings are created from the surfaces of a hand-carved, antique Chinese window shutter and an etched metal door accent from a vintage Chinese armoire. Fluid washes of acrylic and ink are applied on top of the rubbings.

Wet acrylic paint is blotted with a rolled piece of burlap, a crumpled paper towel, a large romaine lettuce leaf and a crinkled plastic grocery bag to create several unique designs.

Solvents can also be brushed or dripped onto the surface of printed matter, moving and reactivating the ink. While wet, sandwiching several prints on top of each other so the ink begins to coalesce infuses the printed surface with an exciting cacophony of pattern, color and texture. If multiple prints are being employed, it's important to separate the sheets every so often so that they don't stick together. Seek printed material that uses coated paper so the ink sits on top and does not absorb into the surface. It is also important that the printed matter be dense with ink and without a varnish on top, as it will not release the ink as easily. The best sources come from high-quality magazines and mail order catalogs that use gravure printing. Sheet-fed or web offset lithography will not produce the same results. When working with any type of solvent, always be sure to follow all health and safety procedures.

A dissolved ink image, created by applying streaks of solvent with a brush, is accented by an acrylic work, which in turn is painted with gouache. The gouache is reactivated with water droplets, exposing the acrylic underneath.

utilizing automatism and freeform painting

To create wonder-filled, imaginative environments, automatism and freeform painting techniques can be employed, enriching the surface with color, pattern and texture. Improvisational approaches invite spontaneous responses, taking the artist on an adventurous ride through the subconscious.

materials

Masonite ¼-inch (6mm) thick
Bristol board

White gesso
Acrylic matte gel medium
Acrylic paint
Oil paint
Liquin
Vellum fixative
Graphite pencils
Colored pencils

Painting knife
Painter's tape
Paint roller
Sponges: natural and synthetic
Round, flat and bright brushes
Sandpaper
Pine needles, pinecones, leaves, bark

1 Finding Inspiration
A springtime nature walk provides engaging shapes, vibrant colors and a fragrant, floral aroma. The experience is used as the emotional catalyst to create an imaginative, abstract environment.

2 Exploring Alternative Tools

Leaves, petals, pinecones, bark and the like are collected and used as alternative mark-making devices.

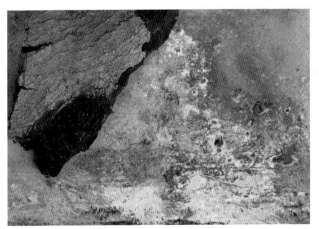

3 Creative Painting and Manipulation

Bristol board is temporarily adhered to Masonite using painter's tape. Relying on the memory of a springtime experience and the emotional connections it inspired, a freeform landscape is created in acrylics. Brushes, sponges, a painting knife and a paint roller are used to apply paint to the surface while pine needles, pinecones, leaves and bark are employed to imprint, blot or distribute paint. The flexible bristol board surface is also lifted, tilted and manipulated to further disperse the wet paint.

4 Costuming and Embellishments

A model is positioned to capture the basic form. A white curtain is draped around the form while a velvet backdrop casts a warm glow. The decorative embellishments that will be added to the costume are drawn flat, filled in with black on the computer, printed onto tracing paper, placed on a dressmaker's manikin and photographed using the same lighting as the original reference. This allows the pattern to be reproduced on the figure in perspective. Shoes will be replaced with bare feet from a separate reference, and a floral element will be added to the headband during the drawing process.

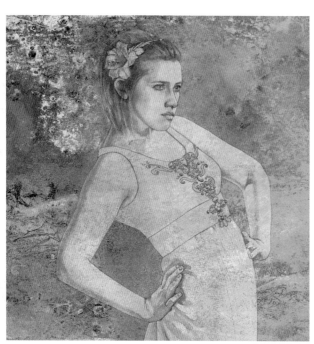

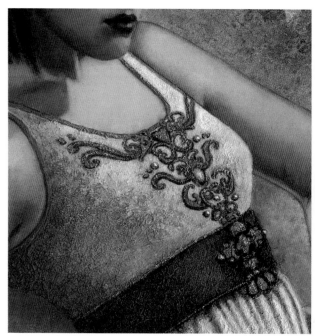

5 Adding the Subject

The subject is blocked in with a wash of Unbleached Titanium White acrylic mixed with white gesso. Light sanding is used to smooth out any rough areas. Using graphite pencils, the figure is added to the freeform background, grounding the environment into a believable reality. Colored pencils are used to bring out the decorative embellishments. To seal the drawing, vellum spray fixative is applied. Always use protective gear and spray in a well-ventilated area.

6 Opaque and Transparent Painting

Acrylic matte gel medium is applied thinly to the dress. Natural elements are used to deboss the wet medium, leaving a subtle texture. Once fully cured, the costume is drybrushed with acrylics, creating a scumbling effect. The embellishments on the dress and the metallic hairpiece are painted with gold, antique copper and bronze acrylic. The mixed-media painting is further developed in acrylics using glazing and wet-into-wet techniques. To finalize the skin tone areas, oil paint and Liquin are employed. The enchanting landscape suggests peace, tranquility and new beginnings.

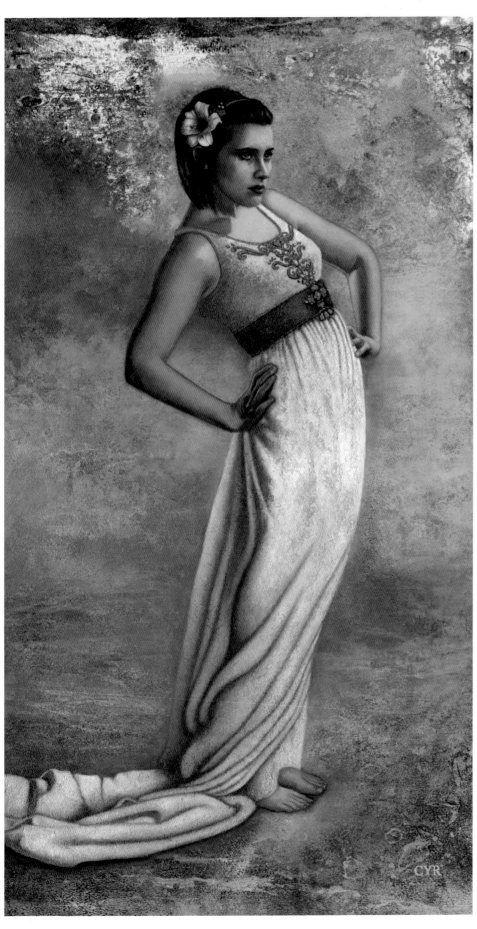

Title: Serenity
Size: 23" × 12½" (58cm × 32cm)
Mediums: mixed media
Surface: bristol board

alternative approaches: creating custom paper

One way to breathe new life into the creative process is to change your approach. Producing a selection of working elements without a specific intent or use already in mind can lead to creative solutions for future challenges. Building a selection of handcrafted collage and assemblage elements will provide a diverse selection of unique additions to be introduced into more finished works.

materials

Masonite ¼-ich (6mm) thick
Bristol board
Printmaking paper
Tracing paper

Acrylic paint
Acrylic matte medium

Flat brush
Paint roller
Flat plastic palette
Plastic bottle with applicator tip
Hair dryer
Brayer
String
Branch with leaves
Painter's tape

1 Mounting the Paper
Painter's tape is placed approximately ¼-inch (6mm) along the outer edges of the backside of a sheet of tracing paper. Once flipped over, tape is placed on the tape area only, allowing the entire surface of the tracing paper to be exposed. Bristol board adhered to Masonite acts as a temporary mounting substrate.

2 Establishing the Color Field
Using a large flat brush, Cadmium Yellow acrylic is applied to the translucent paper surface as a light wash. Once dry, Acra Red Orange is brushed over the warm base color. While still wet, pieces of string are placed on top in an interesting design to absorb the paint. A sheet of printmaking paper is put over the entire surface while it is still wet, and a brayer is employed to blot the excess paint. The pressure applied to the surface leaves an interesting pattern of color and vein-like creases in the tracing paper. To reveal the design, the string is removed once the paint is dry.

3 Adding Natural Patterns

Clippings from a small bush are placed on top of the painted surface. Gold acrylic paint is mixed with acrylic matte medium to the consistency of honey. A plastic bottle with an applicator tip is used to drip the gold mixture on top of the composition in a dynamic fashion. A sponge roller is used to spread the gold paint. Before the paint dries, Acra Red Orange acrylic is applied to a sponge roller and introduced throughout the composition. The clippings are removed, leaving a natural imprint.

4 Tightening the Surface

A hair dryer is used to dry and tighten the painted surface of the tracing paper.

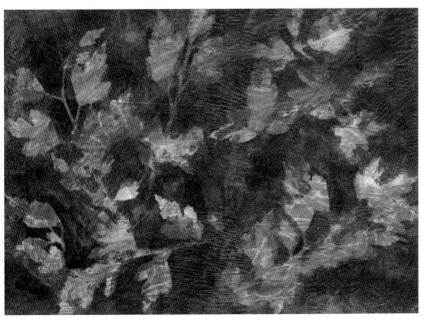

5 Finished Custom Paper

The custom-treated, translucent paper is removed from the mounting surface. It can be used as a collage element in a mixed-media work. Techniques such as folding, wrinkling, creasing or crinkling may be employed before adhering it to another surface.

costuming, props and theatrical settings

"A humble servant by day and a traveler by night, the young peasant girl dreams of a world known only to her in books. In the silence of the dark, the mind wanders past the earthly presence to another realm of existence. Like a captain of a ship, the courageous heart braves the unknown waters to explore new ports over the horizon. Through the amazing journey, she discovers her true potential and her ultimate destiny reveals itself."

The magical presence of the theatrical stage has always intrigued me. I am completely captivated by the fantastical settings, dramatic lighting, elaborate costuming, makeup and props that work in concert, playing an active role in the storytelling process. Drawn into a new reality, I become spellbound and my imagination begins to take flight, sending me off into unchartered territory. Drawing inspiration from the performing arts, a theatrical approach transforms the pictorial surface into a stage, revealing a character or place in a provocative way.

In the mixed-media painting entitled *Voyage to Michaelania*, the viewer is given a glimpse into a young girl's adventures into the depths of her imagination. Breaking free of an earth-bound existence, the child explores an enchanted, magical place called Michaelania. Through the portal of her dreams, a transitional gateway from reality to fantasy is revealed. The child's heightened sense of imagination takes her on a journey of self-discovery where elements drawn from books and everyday life experience are recast into an entirely new role. A free-spirited mix of the conscious and the subconscious, the dream-like voyage exposes the workings of the mind and the inner emotions of the subject. Challenges present themselves in extraordinary ways and the young girl must learn from both the triumphs and the tribulations in order to discover her true potential and purpose in life. Gifted with supernatural abilities as yet unknown to her, the mystic maiden uses her travel adventures to broaden her horizons, opening her mind to newfound possibilities.

To develop the character, I drew inspiration from a series of fantasy-based stories that have been developing in my journals. The costuming, props and embellishments employed on the almost anthropomorphic subject draw from the energy and spirit of the jungle.

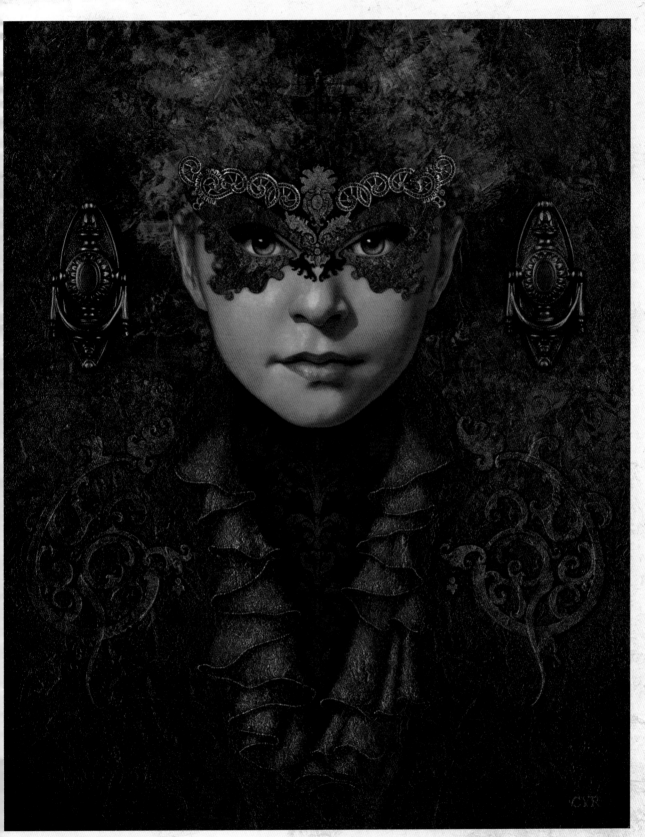

Title: Voyage to Michaelania
Size: 20" × 16" × 2" (51cm × 41cm × 5cm)
Mediums: mixed media
Surface: Clayboard with wooden framework

The supreme rulers of the sky and land, the all-seeing bird and courageous cat, are sourced as visual reference to establish the overall design of the mask which disguises the subject's true identity. When adding surface pattern to the mask, the butterfly was employed as a symbol for transcendence, metamorphosis and flight from an earth crawler to aviator of the skies. The headdress and jeweled embellishments are developed through a layering of jungle-inspired flora and fauna drawings created in a sketchbook. Carried by golden wings, the raised accent at the core of the headdress lifts the young girl's spirit, taking her to places yet unknown but soon to be discovered. The clothing draws reference from the seas, where the ruffled shirt of the sailor captain becomes a metaphor for the waters of life that the main character must travel to discover her true purpose. Placed above the head and in the mind's eye is a dragonfly which symbolizes change and self-realization. The dragonfly is also well known for its relationship to water as a metaphor for insight, wisdom and a deeper understanding of the meaning of life. Whether abstract or representational, each element in the mixed-media composition takes on a specific role in the telling of the provocative, visual tale.

Rather than a slice-of-life scene, the painting captures transitional moments in time, an insightful amalgam of several existences shown in one image. As the eye moves from the bottom of the painting to the facial area, the atmosphere begins to change. The iron gates that once confined become portals to a new, more profound other-worldly experience where door knockers act as a metaphorical entrance to the unknown. When the sun sets and darkness reigns, the maiden voyager drifts off to sleep, sailing her ship onward into the night. With visual acuity diminished, sound, smell and tactile sensations are heightened. To capture the experience, I lit scented candles and listened to recordings of the rainforest while working, conjuring the symphonic sounds that are the heartbeat of the jungle. The melodic environment that ensued became an orchestration of inspired marks, shapes and texture, creating a rhythmic dance for the eye.

Through the voyage of life, we learn that we are not as others see us but instead we are as we see ourselves. Our position in life can never contain or define us. In the vastness of the mind, there are no walls of entrapment except for the ones that we choose to build. The discovery of true potential comes in the process of breaking free of self-induced barriers and limitations to reveal an unparalleled purpose. The young girl's courageous voyage of self-discovery reminds us of our own path in life and the potential that we all have inside us to flourish and prosper, traveling to unchartered territories to make a unique mark on the world.

Visit artistsnetwork.com/experimental-painting for a free altered tool demonstration

materials

Clayboard panel
Bristol board
Printmaking paper
Sketchbook
Decorative doily paper
Handmade paper: fibrous
Transparent plastic sheets
Block of wood: 2" × 4" (5cm × 10cm)

Acrylic paint
Acrylic matte medium
Acrylic matte gel medium
Self-leveling clear gel
Gesso: white
Molding paste
Oil paint
Liquin

Pigment inks
Graphite pencils
Bookbinder's glue: pH neutral PVA
Vellum fixative

Round, flat, bright, fan, bamboo and flat
 contour brushes
Painting knife
Natural sponges
Sponge roller
Craft knife
Wooden stick: sharp at tip
Wire (28 gauge)
Altered paint roller wrapped with string
Toothbrush
Floral fabric lace
Brayer

Stencils
Pastry spatula
Blending stumps
Kneaded eraser
Shaper tool
Cotton cloth
Cotton swabs
Sandpaper
Painter's tape
Plastic wrap
Frisket
Wax paper
Leaves
Brass door knockers
Screws, washers and bolts
Desktop custom die-cutter
Ink-jet printer

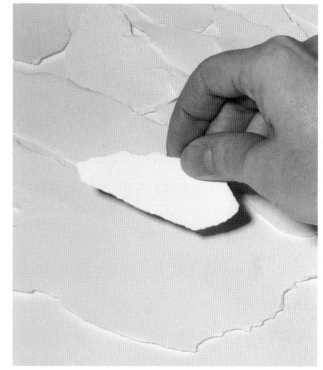

1 Establishing the Subject

The portrait is created by using a variety of elements. The color palette and design inspiration for the mask and jewelry come from the rainforest, including tropical plants, birds and animals. Several studies are created in a sketchbook.

The figure is drawn onto a Clayboard panel surface using graphite pencils, blending stumps and a kneaded eraser. Vellum fixative spray is used to seal the surface. Acrylic matte medium is used to further seal the surface. The Clayboard is naturally very absorbent. Further sealing may be needed if it is absorbing the paint too fast.

2 Texturing the Ground

Bristol board and printmaking paper are ripped into shapes resembling tropical leaves, feathers, flowers and fruit. The pieces are used to build a tactile, visually dense environment. The different absorbency levels allow paint to coalesce in a variety of ways. Once an interesting arrangement of overlapping pieces is established, PVA glue is used to adhere the organic shapes to the panel surface. Wax paper is placed on top and a brayer is used to remove any air bubbles.

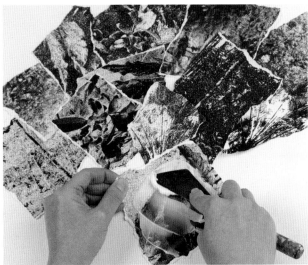

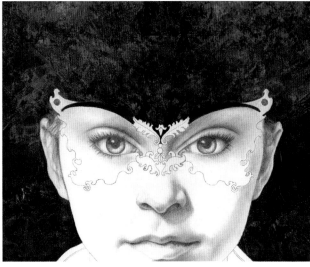

3 Employing Ink Transfers

Black-and-white value studies of tropical plants, birds and animals created in the sketchbook are scanned into the computer and manipulated into graphic line art. Various prints are generated using an ink-jet printer, pigment inks and bristol board. The drawings are coated with acrylic matte gel medium using a painting knife and applied to the painting's paper collage surface. A brayer is used on top to burnish the ink onto the ground. When dry, the bristol board is lifted and the line art is revealed by rubbing away the remaining paper. Some areas remain partially covered while others are removed entirely during the transfer process, creating a sense of mystery. Acrylic matte medium is used to seal the surface.

4 Transparent and Opaque Painting

Using frisket and a craft knife, a mask is cut and placed over the facial area. (See the bas-relief demonstration in the next chapter for details on cutting a mask.) Washes of acrylic paint are applied with brushes to the layered surface, and a cotton cloth is used to blot the wet acrylic paint. An altered paint roller wrapped with string, painting knife and sponges are used to apply more opaque layers. A tropical color palette is employed throughout. Audio recordings of natural rainforest sounds play in the background for inspiration.

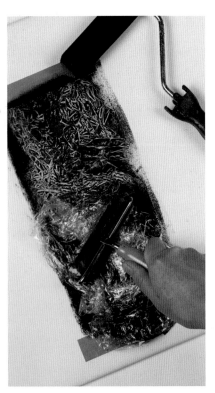

5 Using Monoprinting Techniques

Using frisket and a craft knife, a mask is cut and adhered to the outer perimeter of the figure's neckline. To establish a base color, burgundy acrylic paint is washed over the exposed area and lightly blotted with a cotton cloth. For a printing plate, heavy transparent plastic is adhered to a white rigid surface using painter's tape. Ivory Black acrylic paint is applied to the nonabsorbent surface with sponge roller. Crinkled plastic wrap is pressed into the wet paint several times using a brayer. Before the paint is dry, the custom printing plate is quickly removed from the tape, placed face down onto the masked area of the working surface and burnished on the backside with a brayer. The plate is lifted, revealing a subtle graphic imprint. Acrylic matte medium is later applied as an isolation coat.

6 Adding Multidimensional Embellishments
A jewel accent is designed and scanned into the computer, separated into layers and output onto transparent plastic using a miniature die-cutting machine that can accommodate custom designs. Using a painting knife, molding paste is applied to the working surface three to four times with each stencil. Ample time

for drying and sanding is allowed between each layer. A craft knife is used to make the concentric indentations on the jewel accent. The surface is sealed with matte medium, and the entire accent is painted over with a burgundy acrylic mixture. For a decorative patina, gold and copper acrylic are applied on top with a natural sponge, using one of the stencils as a mask.

7 Using Die-Cut Paper
Paper doilies are painted with a burgundy acrylic mixture, drybrushed with gold acrylic and cut into sections. Using PVA glue, two overlapping layers are separately applied to the area above the mask to accentuate the raised effect.

8 Decorating the Mask
The face mask is blocked in with acrylics, then filled with matte gel medium using a sponge roller. Frisket is used to protect the eye and facial areas. Floral fabric lace is used to deboss the gel medium. Once dry, a second layer of detail is added to key areas using a painting knife. When fully cured, the mask is drybrushed with gold and copper acrylic, highlighting all the raised surfaces. Acrylic paint is also added to the eye area to unify the color scheme.

9 Developing the Portrait

The facial area is blocked in with acrylic washes of Burnt Sienna. Alizarin Crimson is used for the lips. Areas of light are removed with cotton swabs, and a shaper tool develops the finer details. Once fully blocked in, the portrait is further rendered in oils, with Liquin as the medium.

10 Adding the Pattern

Using a custom die-cutting machine, a stencil is made for the neckline pattern. Decorative detailing is added using a mixture of metallic acrylics and a flat contour makeup brush. Several layers of paint are applied to the surface. Glazing is later done to achieve a sense of light and shade.

11 Raising the Surface

Acrylic matte gel medium is applied to the upper perimeter of the mixed-media painting with a sponge roller. Using a pastry spatula, molding paste is added to the lower areas of the piece around the shirt and jacket, which have been protected with frisket. Leaves and floral fabric lace are pressed into the malleable substances. Once dry, acrylic paint is applied on top. In addition, a custom, ironwork-inspired design is added to the composition using a custom-designed series of stencils, molding paste and a painting knife. Because of the complexity of the design, die-cut holes are used to register and line up each stencil. When fully cured, the raised surfaces are sanded lightly and washes of acrylic paint are applied on top to establish a base color. Once dry, gold and copper acrylic paints are drybrushed on with a fan brush. Additional paint is sponged onto the peak areas.

12 Creating a Custom Debossing Stamp

Fibrous handmade paper is primed and treated with gesso to create a custom stamp. A wash of Burnt Sienna acrylic applied on top helps to expose the texture. When dry, the treated paper is adhered with acrylic matte gel medium to a block of wood.

13 Using the Custom Stamp

The ruffled shirt and coat are blocked in with acrylics to build the form. A decorative design is created by applying acrylic matte gel medium with a sponge roller and then debossing it with the custom stamp. The surrounding areas are protected with frisket. Once the medium is fully cured, the textured design is accentuated by drybrushing with gold and copper acrylic paint and a fan brush.

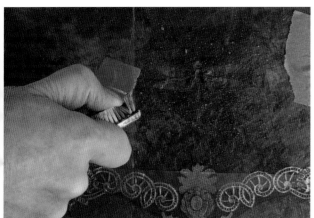

14 Employing Sgraffito and Spattering Techniques

A dragonfly design is added to the upper area of the painting using a combination of sgraffito and spattering techniques. The main body is painted with a brush in acrylic, and a sharp wooden stick is employed to carve into the surface. To create the wings, a mask is cut and self-leveling clear gel is applied generously to the surface. While still wet, liquid acrylics are dropped into the wet medium using the tip of a round brush. A piece of thin 28-gauge wire is used to manipulate the wet media and create a unique design. Once this is fully dry, acrylic matte medium is brushed on top to even the surface and dull the shine of the clear gel. To create reflective highlights on the wings, spattering is done using a toothbrush dipped into liquid gold and copper acrylic. A thumb is used to disperse the fine mist. Clear plastic and a custom die-cut stencil are used to mask the surrounding areas.

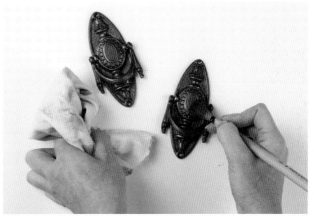

15 Attaching the Hardware

Two vintage brass door knockers are drybrushed with Antique Copper acrylic paint using a bamboo brush. A cotton cloth is employed to wipe off areas. Rounded screws are sanded at the top, filled with molding paste, treated with layered drops of gesso and painted with gold and copper acrylic paint. Holes are drilled into the panel and the decorative accents are attached to the composition with the altered screws, which are held in place with washers and nuts in the back.

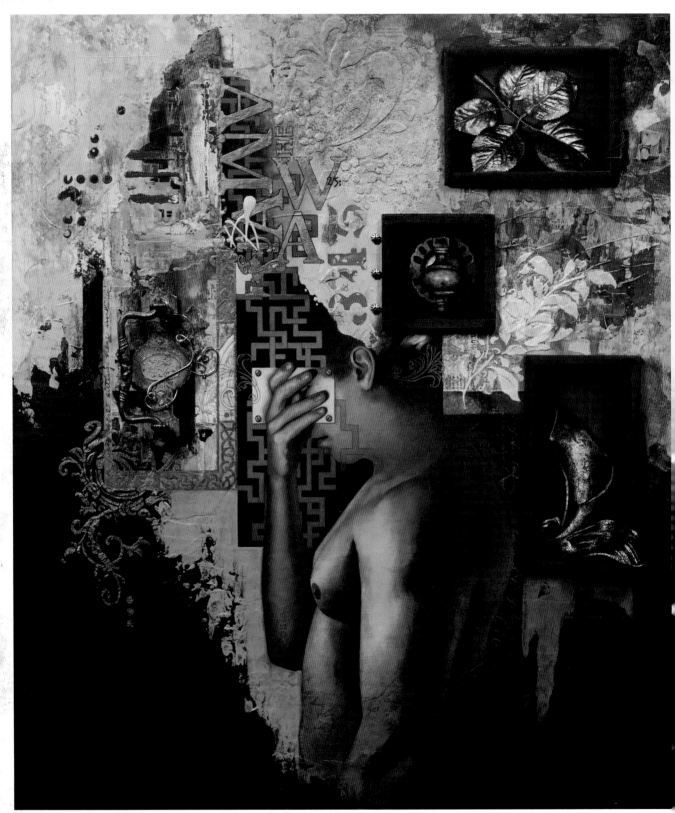

Title: Meditative Pathways
Size: 20" × 17" × 2" (51cm × 43cm × 5cm)
Mediums: acrylic, oil, ink, graphite, modeling paste and acrylic gel medium
Materials: wire, beads, tissue, ephemera, decorative metal accents, clay and wood
Techniques: collage, assemblage, sculpture, dripping, sanding, scraping, spattering, sponging, peeling back, painting knife and type transfer
Surface: linen canvas over Masonite panel with wooden framework and inlaid boxes

unique constructs and assemblage accents

The physiognomy of the pictorial surface is being altered to encompass a multidimensional, hybrid environment, a perfect synthesis of lushly painted tactile surfaces and inventive sculptural creations. Establishing a dynamic relationship between form, structure, space and concept, unique constructs and assemblage accents create an engaging, visceral experience. Like a theatrical presentation, they captivate the imagination and ignite the senses, drawing the viewer in from almost any direction to establish a memorable and lasting connection.

Exploring Materials and Processes

Within the multidimensional pictorial stage, myriad materials and processes are being exploited. From rigid substrates such as metal, wood, plaster and polystyrene foam to more flexible surfaces such as acrylic polymer, plastic, wire mesh and leather, diverse materials are being introduced into the three-dimensional landscape.

Carved, cast, molded, etched, embossed and embellished surfaces infuse texture and create visual interest, while the addition of enclosed boxes, windows and cages adds depth and sculptural illusion, building the relief surface in a way that imbues mystery and intrigue. With the presence of static and free-moving add-ons and accents such as ticking clocks, swinging pendulums, miniature robotics and battery-operated devices, cognitive interpretation is enhanced, enlivening the dimensional landscape with enticing visual clues as to the overall messaging of a work.

Custom Treating and Repurposing

From leaves, flowers, twigs, feathers, driftwood and shells to vintage hardware, nostalgic techno-parts and relatively new objects that have been repurposed and custom treated, both natural and man-made elements are finding their way into the multidimensional, mixed-media painting oeuvre.

To harvest unique trinkets of time, antique shops, auctions and vintage dealers online as well as yard sales, flea markets and junk yards are just some of the resources being used by the mixed-media artist. When it comes to repurposing, frame shops, craft retailers, culinary outlets, hardware stores and fabric retailers can provide objects and materials that can be custom treated. With the addition of faux finishes and decorative techniques, the everyday object or surface can be transformed into a one-of-a-kind find.

With the introduction of visually compelling and thought-provoking sound chips, video installations and holographic, lenticular tip-ins, the pictorial experience is further heightened, expanding the boundaries of what is possible in visual communications. Advances in technology have opened the floodgates for the pictorial stage to not only converse but also to interact with the onlooker in a way that is provocative and meaningful.

Balancing Form and Function

When working in the third dimension, visual aesthetics often must incorporate structural concerns. To ensure solid construction of a multi-piece assemblage, certain skill sets need to be introduced into the creative repertoire. Carpentry knowledge, experience with sculptural techniques or an understanding of metalsmithing can each play an important role in the construction of a multi-surfaced, multidimensional mixed-media work of art.

If an artist's skills or access to materials are limited, there are other alternative approaches to explore. Through the use of simulated surfaces, maintaining the aesthetics of a work's original intent without the drawbacks that may come from constructional limitations is possible. The look of wood, metal and plaster can be easily be achieved using simple faux painting techniques. With the addition of distressing and aging applications, simulated surfaces take on an authentic, time-tempered look and feel.

Redefining the Pictorial Stage

The methodology of picture making and the role of the pictorial stage are being redefined from the working ground up. Architectural constructs and assemblage accents allow pictorial content to take on a more physical manifestation, introducing imaginative, thought-provoking, meaningful narration to communicate a concept and illuminate a subject.

Carved, cast, molded, etched, embossed and embellished surfaces infuse texture and create visual interest while the addition of enclosed boxes, windows and cages adds depth and sculptural illusion, building the relief surface in a way that imbues mystery and intrigue.

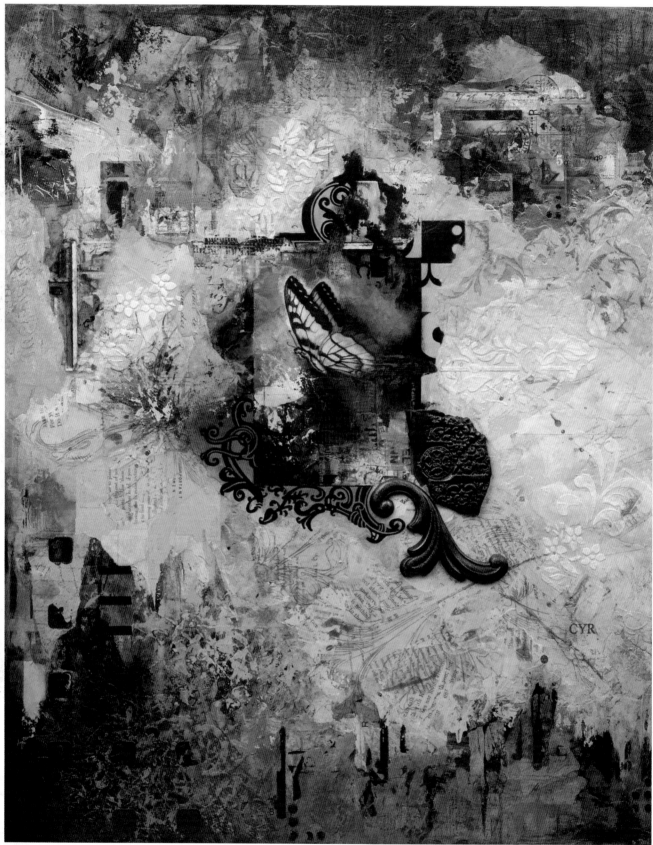

Title: The Creative Spirit Within
Size: 22" × 17½" × 1¾" (56cm × 44cm × 4mm)
Mediums: acrylic, oil, ink, graphite, modeling paste and colored pencil
Materials: textured paper, tissue, ephemera, die-cut paper, clay and wood
Techniques: collage, assemblage, sculpture, sanding, scraping, peeling, spattering, painting knife and type transfer
Surface: linen canvas over Masonite panel with wooden framework

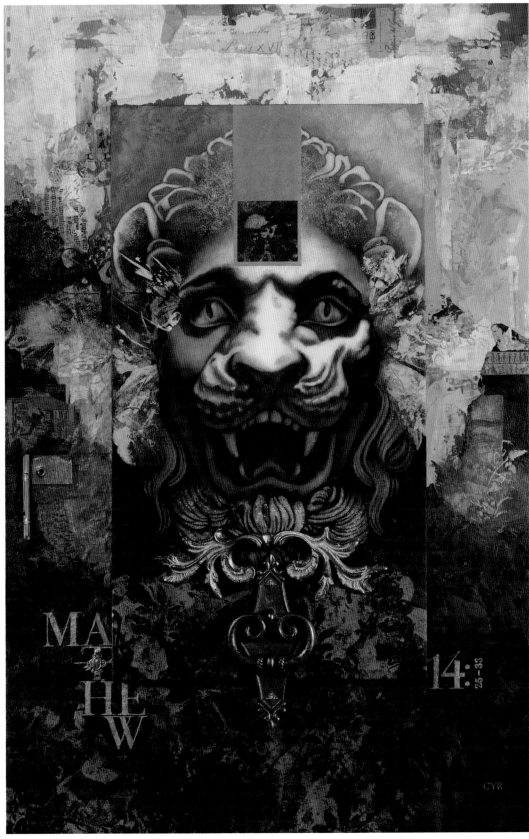

With the presence of static and free-moving add-ons and accents, cognitive interpretation is enhanced, enlivening the dimensional landscape with enticing visual clues as to the overall messaging of a work.

Title: The Courageous
Size: 30¼" × 19" × 2½" (77cm × 48cm × 6mm)
Mediums: acrylic, oil, gel medium and modeling paste
Materials: ripped, cut, riveted and punched textured paper, ephemera, sticks, thread and metal
Techniques: collage, assemblage, embossing, debossing, monoprinting, sponging and painting knife
Surface: linen canvas over Masonite and board with wooden framework

faux surfaces, finishes and patinas

To infuse character, time-tempered history or aesthetic ornamentation into their work, artists are creating simulated surfaces, employing distressing and aging techniques and adding decorative finishes onto a wide range of substrates and assemblage accents. The addition of faux surfaces, finishes and patinas allows for the creation of unique add-ons or environments.

Simulated Surfaces

When working with unorthodox substrates, sometimes issues of constructional limitations, weight, paint adhesion or permanence can be a concern. Through the use of simulated surfaces and faux techniques, other options allow the visual aesthetics to be maintained without the restrictions or drawbacks. Solid gold, brass, copper, pewter, steel or aluminum can be easily imitated with the application of metallic paints or imitation foils onto any surface. With the addition of etching, sculpting, embossing or the introduction of add-ons such as bolts, screws, grommets, wire and other accents, the faux surface can appear quite authentic. Whether raw, stained or painted, wood can also be easily simulated. Graining instruments or treated brushes can assist in the application of natural grain and texture.

To achieve the look of cast plaster, artists are utilizing an engaging array of techniques and materials onto a plethora of rigid substrates. For a bas-relief, fresco-like appearance, debossing using a heavy textured material into acrylic gel medium, coarse pumice gel, modeling or molding paste can create visually expressive, exquisitely tactile surface detail. In addition, embossing using custom stencils and heavy gel medium or paste can also establish a highly dimensional, raised effect. To introduce decorative add-ons and accents, polymer clay, self-drying clay and even paper mâché are being used, as each can be easily glued or screwed on to a rigid support. Molding paste and a pastry decorating bag with a diverse array of applicator tips are also being employed to incorporate small details and accents into the dimensional composition. In addition, decorative trim, ribbon and lace as well as natural and synthetic fabrics can be transformed into bas-relief when treated with acrylic gel

medium, gesso or encaustic, shaped and left to harden on the working surface. With the application of painted patinas, the sculptural surface establishes the illusion of a decorative wall motif.

Distressing and Aging

Many artists are exploring what Mother Nature can do to alter the surfaces, add-ons and accents used in mixed-media painting. They are collecting fairly new objects, materials and ephemera and exposing them to the short- and long-term effects of natural elements. Sun bleaching, staining, corrosion and rusting are just some of the patinas being achieved.

But if time is of the essence, there are faux techniques that can speed up the aging process. Metal can be prematurely rusted and corroded by abrading the surface with sandpaper and randomly applying acrylic matte medium or resin sand texture gel for heavier corrosion. With the addition of Payne's Gray and Burnt Sienna acrylic washes, the surface begins to mature. Wood can also be aged and distressed before its time by using sanding, scratching, denting and cracking techniques. For a worn and weathered appearance, clear crackle varnish can be introduced amongst built up layers of acrylic paint, breaking the surface with both large and small cracks. Sanding back into the visually aged substrate can further add believability. For a more sun-bleached look, painting thin washes of color onto a raw wood surface can be quite effective. When it comes to a more fresco-like appearance, crackle paste applied heavily onto a rigid substrate can establish a highly weathered look with deep areas of craquelure. A dark, neutral-toned wash that has been wiped away will sit in the crevices, enhancing the dimensionality and metamorphosis of the plaster-like environment.

To infuse an authentic-looking vintage patina onto printed or photocopied materials, staining the paper surface with tea or coffee is being done with distinctive results. To age and distress printed matter and ephemera, I like to use acrylic matte medium and a painting knife, dragging the medium over the paper surface in a random way. Once dry, Yellow Ochre acrylic paint can be lightly washed onto the paper surface, wiping away

1 Tracing paper is spattered with acrylic paint, crinkled and drybrushed with metallic silver acrylic.

2 A painted background is imprinted with a sprig coated with embossing ink. The wet ink is covered with embossing powder and a heating element is employed to raise the gold surface.

3 Synthetic mesh is dripped with liquid acrylic and sponged with gold.

4 Self-leveling clear gel, liquid acrylic and metallic interference paints are swirled with a sharpened stick, then left to harden in a flat mold and later removed.

5 Acrylic paint is dropped into matte gel medium and marbled with a wide-tooth comb.

6 Facial tissue is folded, manipulated and adhered to a surface using acrylic matte medium. Washes of acrylic paint are applied on top.

7 Handmade paper embedded with natural fibers is primed with gesso; washes of Burnt Sienna and copper acrylic are applied on top. The raised surface is wiped with a cloth to reveal a textured pattern.

8 Corrugated cardboard is adorned with pearlescent acrylics and dripped with latex paint.

9 Debossed wallpaper is imprinted using leaves and acrylic paints.

10 A paper doily is treated with silver acrylic and adhered to a painted surface. Brown ink is applied on top while the surface is sprayed with a water bottle. The ink puddles and begins to drip while the excess is removed with a paper towel for a weathered appearance.

11 Gold and copper acrylic is sponged on top of a black base using a large sponge with irregular holes.

12 Heavy-duty aluminum foil is crinkled and manipulated to create an embossed surface. Black ink is applied to the surface and wiped away to create an interesting patina.

most of the paint before it thoroughly dries. Some of the acrylic will absorb into the paper while other areas will be washed away, transforming the crisp white surface into something that reveals a history. I find that absorbent, durable papers such as printmaking and watercolor papers work best.

A distressed faux metal surface is created using layered strips of ripped black tape with acrylic matte gel medium randomly applied on top with a painting knife. Dry-brush applications of Burnt Sienna and pewter acrylic paint as well as washes of Payne's Gray add to the aged metallic look of the polystyrene foam surface.

A worn, weathered wood surface is simulated onto polystyrene foam. With clear crackle varnish, dry-brush painting, random painting knife applications, sanding and washes of Burnt Umber acrylic over Unbleached Titanium White acrylic surface, the effect of distress is produced almost instantaneously.

To age a photographic picture or fully rendered painting, the addition of clear aging and cracking varnishes can be quite effective. To protect the integrity of the image, the area to be treated needs to be fully covered with several coats of a clear fixative. Additional protective layers of matte medium should be applied to further seal the surface. Using a brush, the oil-based aging varnish is applied first and allowed to dry to the touch. The longer the drying time, the smaller the cracks will be. Temperature and humidity will also vary the results. The water-based crackling varnish is then employed on top in even stokes. Oil paint rubbed on and wiped away with a cloth will help to enhance the dimensionality of the broken and aged surface.

Other distressing techniques include heating, burning or slightly melting a surface or object. It is very important to be aware of the toxicity of certain materials once they are heated. Changing the physical state of a surface or object can make it unstable, hazardous and even explosive, depending upon the chemical makeup. When employing an unorthodox process, it is always best to seek technical advice from the manufacturer before embarking on any alteration to a material or compound.

Decorative Finishes

From embossing metal and gilding to marbling, combing and sponging techniques, a provocative array of decorative finishes are being explored. To create a raised metal surface or accent, artists are using tooling foil and embossing it with a texture or custom design. Gilding using metal leaf applied with sizing over a bas-relief accent or surface texture can also establish a decorative, tactile presence. Another way to create an embossed metallic look is to use embossing powder. To transfer a custom design onto the surface, a hand-carved printing block made of linoleum, soft wood or even a white eraser-like vinyl material can be used in conjunction with an embossing ink pad. For more freeform effects, an embossing pen can be employed with distinctive results.

Decorative and specialty paints such as metallic, fluorescent, phosphorescent, interference, pearlescent and glitter-infused pigments offer intriguing effects when used in conjunction with mixed-media techniques. When added to an acrylic medium or self-leveling clear gel and manipulated with a stick, comb or feather, the combination establishes a dynamic, robust environment. For a more impasto-like look, gel medium can be used with a hair comb or pick to create a marbleized effect that is quite dimensional. Sponging can also be a nice decorative addition to any surface. The more irregular the holes are in the sponge, the more unusual the imprint

Shown is a detail of self-leveling clear gel poured on top of a heavy molding-paste carved surface. Liquid acrylic and waterproof black ink are dropped into the wet medium, swirled and manipulated to create a distinctive design.

will be. I find that decorative sponging works best when it is layered onto a surface, infusing specialty paints into the mix.

Using clear acrylic polymer imbedded with acrylic paint or ink, a unique surface can be built up in layers. Both natural and synthetic materials and bas-relief objects can also be introduced, creating the appearance of an encaustic-based work. To create acrylic polymer substrates, self-leveling clear gel can be applied evenly to a nonstick surface. A plastic container with a completely flat bottom and a very low height or an acrylic palette with an inset tray works best in maintaining a consistent shape. While the base medium is still wet, liquid acrylic paint or ink can be dropped onto the surface and manipulated. Once fully cured, the flexible surface can easily be removed from the mold. The polymer-based art can function as a stand-alone piece, a collage element to another work or an assemblage accent that has been molded, shaped or wrapped over another object or surface.

A sculptural surface is created using cotton cloth coated with a mixture of molding paste and gesso on both sides. Before it dries, it is adhered to a primed polystyrene foam base. The hardened cloth surface is further treated with gesso, distressed with crackle varnish, textured with resin sand texture gel and painted with acrylics.

creating custom add-ons using clay

materials

Polymer clay
Wire
Acrylic paint

Rolling pin
Metal ruler
Craft knife
Sponge
Round and flat brushes
Wooden stick: sharp at tip
Sculptor's carving tool
Metal cup with handle
Muffin pan
Nonstick surface
Conventional oven

Using sculptural techniques, custom add-ons and accents can be incorporated into the pictorial environment, presenting tantalizing visual clues to the overall message of a work. Self-drying and polymer clay, plaster, metal, wood, urethane foam and pâper maché can be transformed into one-of-a-kind creations.

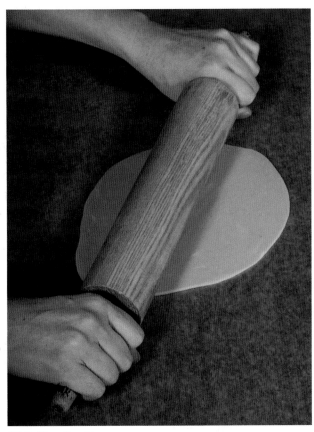

1 Rolling the Clay
On a nonstick surface, polymer clay is rolled out with a rolling pin to a uniform thickness.

2 Cutting the Components
Six rectangles as well as a square base are cut out of the polymer clay with a craft knife and metal ruler.

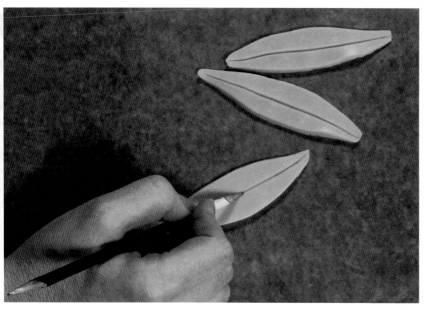

3 Creating the Petals

The rectangular pieces of clay are cut into petals with a craft knife. A wooden stick is used to carve the center line into each petal.

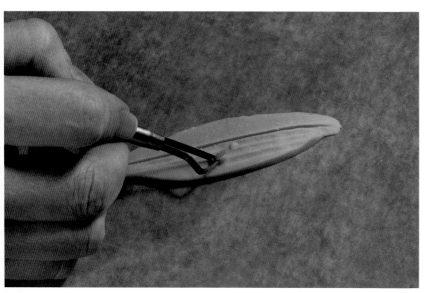

4 Adding the Texture

Texture is added to each petal using a sculptor's carving tool. Water is applied with a soft round brush to remove any debris.

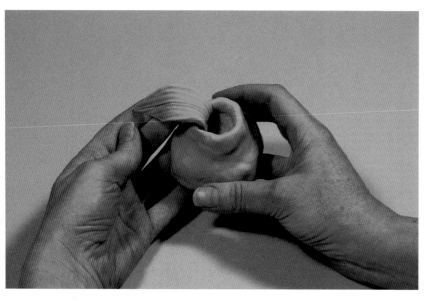

5 Building the Flower

A receptacle is built for the base of the flower. Each petal is placed into the base and shaped.

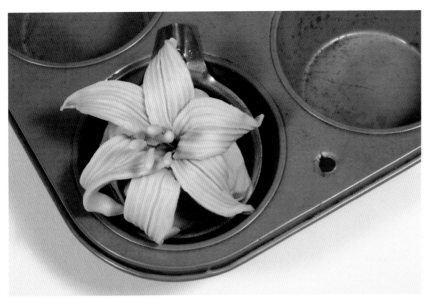

6 Baking the Clay

Several pieces of wire with polymer clay at the tips are inserted into the central area of the flower. The sculpted flower is placed in a metal cup with a handle, which will allow the sculpture to be removed more easily after it is baked. The cup and sculpture are then placed inside an old muffin pan. The clay is baked in a preheated, conventional oven at 275° Fahrenheit (135° Celsius) for 15 minutes per ¼ inch (6mm) of thickness and then allowed to cool.

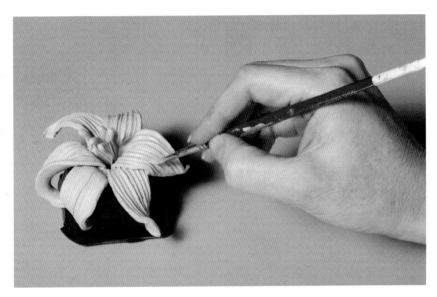

7 Applying Color

A base color is applied to the hardened sculpture with acrylic paint and a brush.

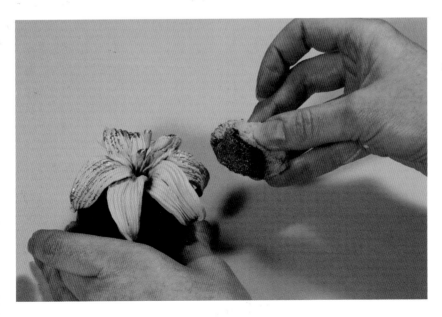

8 Adding a Patina

Using a sponge, gold acrylic paint is randomly applied to the surface.

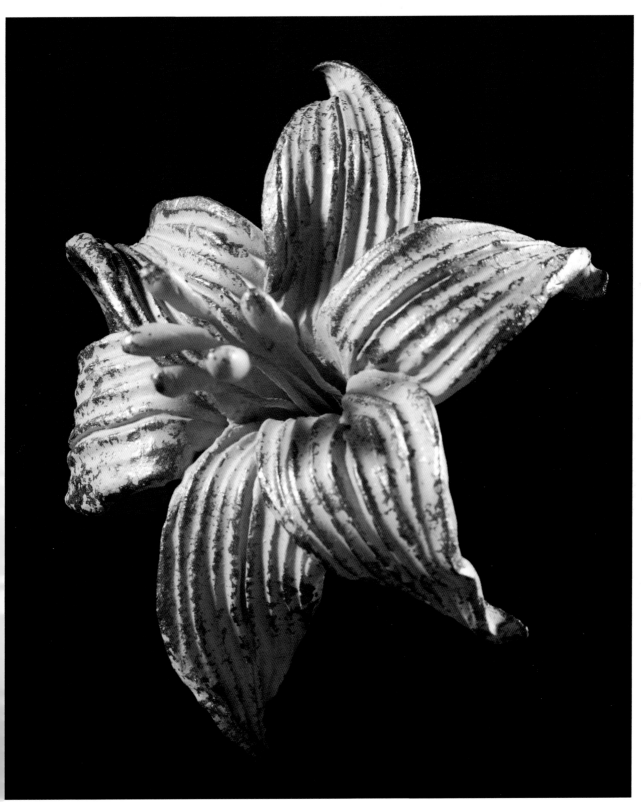

9 **Finished Custom Add-On**
The floral accent can be placed inside a dimensional panel with an inlaid box or it may be held in place with screws through holes that have been drilled from the back of a rigid support.

working in bas-relief

With the addition of bas-relief, sculptural treatments and matter painting—which incorporates thick, impasto applications of gesso, paste or gel mixed with materials such as sand, sawdust and other fibrous materials—the picture plane defies its flat existence and becomes revitalized. Uniting the disciplines of painting and sculpture in inventive combinations, alternative topographic applications transform the pictorial landscape, creating a highly tactile environment that ignites the imagination.

Masonite ¼" thick (6mm)
Poplar wood strips ¾" × 1½" (19mm × 38mm)
White bond paper
Layout paper
White tissue paper
Handmade paper
Textured wallpaper
Frisket
Beach sand, sawdust and leaves
Branches with leaves
Decorative wooden accents

Acrylic paint
Acrylic matte medium
Acrylic gel medium
White gesso
Oil paint
Liquin
Powdered graphite and pencils
Fine tip ballpoint pen
White Conté stick
Foliage preserver
Bookbinder's glue: pH neutral PVA
Vellum fixative

Painting knife
Synthetic and bristle brushes: flat, round and bright
Brayer
Craft knife
Various sponges
Sponge brush
Shaper tool
Sponge roller
Wooden stick: sharp at tip
Sandpaper and sanding block
Cotton cloth
Paper towels
Wax paper
Screws
Computer and scanner

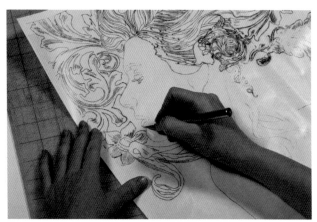

1 Cutting a Mask
A comprehensive line drawing is created to scale, scanned into the computer and printed out on white bond paper. Frisket is applied to the paper surface and a mask is cut using a craft knife with a new blade.

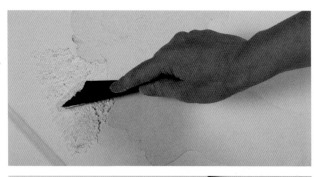

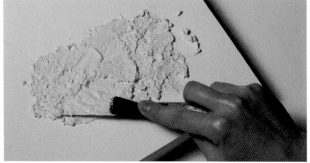

2 Utilizing Matter Painting
The frisket is applied to a gesso-primed dimensional ground made of Masonite and poplar strips. White gesso mixed with sawdust is applied around the facial areas with a painting knife. For a deeper texture, gesso mixed with beach sand is placed in the other areas surrounding the figure. The two different textures suggest the elements of earth and water.

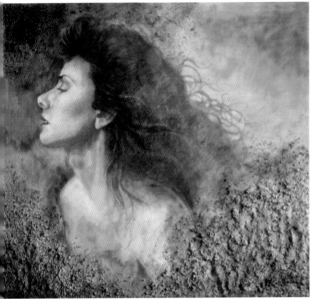

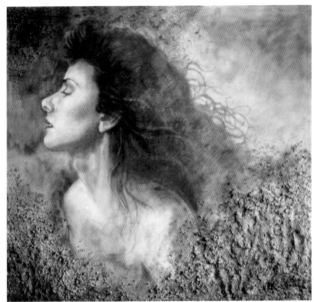

3 Establishing the Drawing

Powdered graphite as well as graphite pencils are used to create a monochromatic drawing of the subject. Bristle brushes that have been trimmed are used for the textured areas while soft nylon brushes are employed for the smoother surfaces. Several coats of vellum fixative spray are used to seal the drawing. Always use protective gear and spray in a well-ventilated area.

4 Applying a Key Color

A cool Viridian Green acrylic paint mixed with water is washed over the entire piece. Areas that are to remain white are wiped out with a cloth. Once dry, the piece is sanded with a sanding block to eliminate unwanted peaks in the matter painting. A coat of warm Permanent Green acrylic paint is applied on top. The cooler color stays in the crevices while the warmer tones remain on top. From instability to balance, the symbolic interpretations of the color green make it a perfect tonal hue for the overall concept in this piece.

5 Adding Tissue Texture

To create movement and unify the various textures, creased white tissue paper is added to the surface using acrylic matte medium and a brush. Once it is dry, acrylic matte medium is applied on top as a sealant.

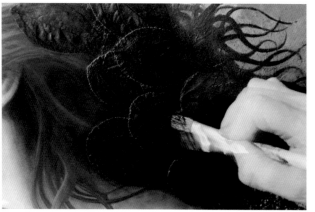

6 Employing Organic Elements

Leaves are soaked in foliage preserver. The solution helps to maintain the suppleness of the leaves, preventing them from cracking. Once fully cured (7 days to 3 weeks) and dried with a cloth, they are added to the working surface using PVA glue and a soft brush. Acrylic paint is applied on top to incorporate the organic elements into the color scheme. The green leaves, symbols of growth, are placed in an overlapping fashion behind the figure's head to show movement and to symbolize moving beyond difficult times to a place of strength and renewal.

7 Blocking in the Colors

The main areas of color are blocked in with acrylics. Oil paint and Liquin are used to render the details.

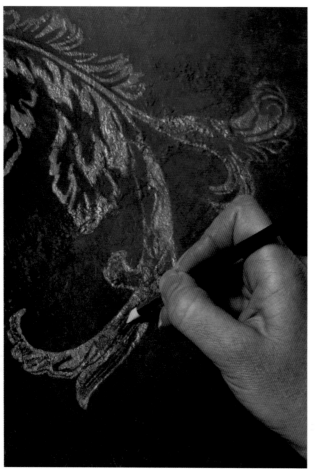

8 Applying Decorative Accents

Decorative accents are applied to the working surface using a fine ballpoint pen and a white Conté transfer sheet made by rubbing a Conté stick onto a sheet of layout paper and blending it smooth. A fine brush is employed to paint the details in gold oil paint. A shaper tool is used to remove paint in the smaller areas of detail.

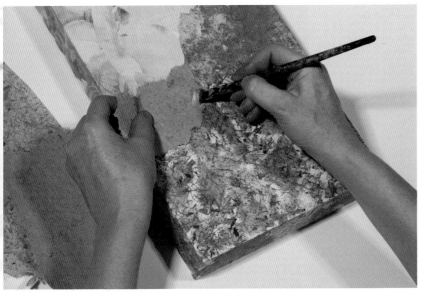

9 Adding Textural Collage

Textured wallpaper and handmade paper infused with organic elements are added to the top and sides of two custom-built dimensional accent panels using PVA glue. A brayer is used to remove any air bubbles. To seal the surface, acrylic matte medium is applied with a soft brush.

10 Employing Sculptural Relief

Gesso diluted with water is applied to all sides of the two accent panels with a soft flat brush, priming the surface and unifying the collage elements. Once dry, another layer of heavy gesso is applied to the surface using a painting knife, blending the areas of transition. To create movement and energy, liquid gesso is dripped from a stick.

11 Toning and Blotting the Surface
Several washes of green liquid acrylic paint are applied to the side panels. Paper towels are used throughout to blot the surface and lift areas of color in a dramatic way.

12 Adding Color
Acrylic paint is applied to both side panels using traditional brushes and a sponge brush, incorporating colors from the main central image.

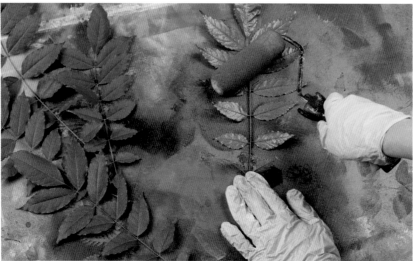

13 Monoprinting the Surface
The backsides of several small branches with leaves attached are painted with gold acrylic in a random way using a sponge roller. The branches are laid on the surface of both accent panels using wax paper on top, and a brayer is used to apply pressure. Several imprints are made. To bring out the textured surface, a sponge is used to skim peak areas with gold. For the accent panel on the left, washes of Magenta acrylic are applied between the imprinted layers to create distinction and depth.

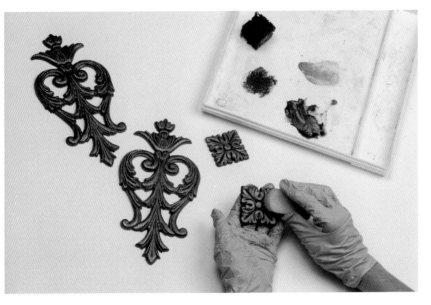

14 Employing Dimensional Accents

Decorative wooden accents are sanded along the edges and painted with Bronze acrylic and a brush. Antique Copper is sponged on top with a natural sponge to create an organic texture. Once dry, a smooth sponge is used to brush gold acrylic onto the top surfaces, allowing the Bronze and Antique Copper to show through in areas. For the finishing touch on the square accents, Champagne Gold is applied on top with a sponge. Each decorative accent is adhered to the panels using acrylic gel medium.

15 Pulling It All Together

The two 19¼" × 8" (49cm × 20cm) accent panels are positioned on either side of the 19¼" × 19½" (49cm × 50cm) central panel. The mixed-media triptych is titled *Fluidity*. A self-portrait of sorts, the piece is about riding the wave of life, remaining fluid in the midst of both triumphs and tragedies.

pluralism and nonlinear storytelling

"It's the dawn of a new day. The morning light sparkles and shines on the lake, casting its warm embrace through the cool mist. A water lily's soft and fragrant white petals open like a pearl breaking free of its shell, ready to receive the sun's undoubting affection. The sweet, symphonic sound of birds resonates throughout the land and the Lady of the Lake watches like an overlord from the depths below."

In my work, I am interested in a nonlinear, pluralistic approach to storytelling, where pictorial elements transcend their graphic posture to undertake multiple roles in the recitation of a tale. Unlike a monolithic presentation of a slice-of-life scene where everything is revealed, a concept-based, pluralistic work leaves the door open for imaginative interpretation. A rhythmic synthesis of thought-provoking imagery, symbolic iconography and elusive topography creates a breeding ground for the mind. Taken out of their ordinary chronological order, narrative elements are recomposed with an entirely new choreography, one that is much more poetic and even symbolic. The reading of a work becomes nonlinear, presenting only fragments or hints to a story rather than a literal rendering. Sights, sounds, aromatic references and tactile sensations abound, stimulating curiosity and thoughtful observation over time. The viewer is encouraged to look deeper into the work to discover the mysteries beneath the surface. By challenging the intellect, evoking the senses and igniting the imagination, the viewer is invited to play a cognitive role in the overall messaging.

In the painting entitled *Lady of the Lake*, I drew inspiration from my love of the legendary Arthurian tales. I wanted to create a magical environment, one that would evoke the enchantment and mysticism of

Title: Lady of the Lake
Size: 31½" × 22" × 8" (80cm × 56cm × 20cm)
Mediums: mixed media
Surface: wood with plaster accent

epic medieval folklore. Using symbolism and pluralistic, nonlinear storytelling, I developed a multilayered, mixed-media work that reveals a robust history, where each layer influences the next. Throughout the densely tactile composition, pictorial elements take on myriad functions and the visual field comes alive with new interpretations and meaning. Shape, color, texture and type move beyond their graphic, pictorial status to create a vision that communicates more than the sum of its parts. Decorative floral accents, ornate Celtic graphics and medieval prose elegantly dissolve in it out of the space encompassing the central subject like hidden messages to a more complex story. Excalibur, the majestic sword that is so tightly interwoven with the Arthurian stories surrounding the Lady of the Lake, is presented in a highly symbolic, graphic interpretation instead of an explicit translation. To establish Excalibur's presence above the water, I used embossed typographic prose reminiscent of the tales told of this mystic symbol of heroism. Below the water's edge, Celtic and medieval iconography serve as graphic representations of the sword and its magical scabbard. The ambiguous subtleties of the reinterpretation create mystery and intrigue, coloring the entire visual field with relevant, meaningful symbolism.

The multilayered construct is also highly symbolic and significant to the overall messaging of the work. Typically, the Lady of the Lake is portrayed from a vantage point above the lake looking down. I chose to completely alter the frame of reference so the picture is from the mystical maiden's perspective at the bottom of the lake looking upward. A guardian-like figure, she dominates the work. With each concentric layer of the multi-paneled framework, we are brought ever closer to the water's surface. The architectural rails strike distinct borders of the Lady of the Lake's reign below. The color palette, predominantly cool with an accent of warm, helps to make a distinction between the innocence and beauty of the world above the water's surface and the hidden, dark, fiery depths that exist below the horizon.

Within the concept-based, pluralistic realm, opposing ideas can be presented simultaneously. The timeless tales of King Arthur present a clash between good and evil, where each encounter profoundly affects what is to come. Stories of chivalry, bravery and heroic, noble deeds coalesce with deception and deceit. Although the triumphs, trials and tribulations of today present different challenges than that of medieval times, there is still something that remains true: life is an ongoing quest for meaning and the feeling that we are all connected and part of a greater whole. Each passage of our existence becomes an interwoven layer of experiences and relationships that propel our evolution as human beings in an imperfect world.

Multiplicity in concept as well as approach allows for more complex, sophisticated communications to take place. Multi-sensory, multilayered works engage, provoke and challenge the mind, inviting the viewer to personally invest in the work. Over subsequent visits, something new always presents itself. With further observation, alternative connections are made, fostering the relevance as well as the longevity of the work.

materials

Decorative panel
Hardwood panel
Wooden balusters
Plaster sculpture
Wooden dowel
Papers of various weights and finishes
Tissue paper
Tracing paper
Layout paper
Bond paper
Heavy lace fabric
Royalty-free Celtic and medieval graphics

Acrylic paint
Acrylic matte medium
Acrylic matte gel medium
Stain-resistant primer
Modeling paste
White gesso
Oil paint
Liquin
Conté stick: brown
Fine point ballpoint pen
Gold embossing powder
Embossing ink pad
Wood filler
Polyurethane construction adhesive

Round, flat and bright brushes
Painting knife
Sponge
Rubber stamp with script
Embossing heat tool
Floral stencil
Paper towels
Router with decorative bit
Sandpaper
Painter's tape
Screws
Drill

1 Establishing the Structure

The multidimensional structure is made of several disparate parts. An antique decorative panel is used as the base. Two wooden balusters that were originally different sizes are adjusted with a wooden dowel and wood filler to make them equal length. An antique plaster sculpture is also employed.

2 Treating the Surfaces

The decorative panel is painted with Burnt Sienna acrylic. To add a patina to the surface, a mixed turquoise acrylic is applied with a large brush and blotted in areas using a crinkled paper towel. The balusters and the plaster sculpture are also painted with Burnt Sienna acrylic. The turquoise mixture is applied to the balusters with a bristle brush and to the sculpture with a sponge.

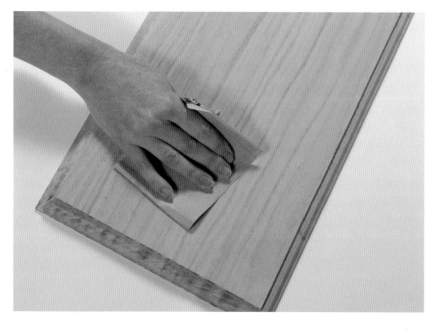

3 Beveling the Working Ground

A hardwood panel is cut to fit inside the structure's framework. The sides are beveled using a router with a decorative bit. The entire panel is sanded smooth.

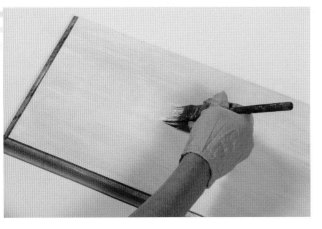

4 Priming the Surface

The custom-cut panel is treated with a stain-resistant primer and several coats of acrylic gesso. Light sanding is done between each layer of gesso.

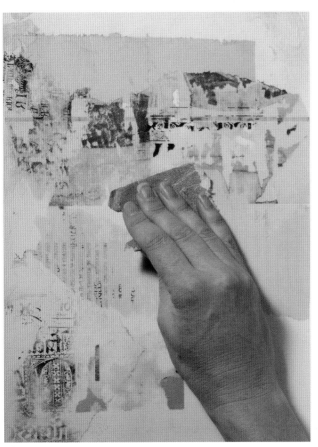

5 Creating the Background

To create a dense environment, Celtic manuscript text and graphics are printed on white bond paper. The paper is coated with acrylic matte gel medium and applied to the working surface face down in layers. As each layer dries, the printed paper is partially ripped off, leaving some areas showing the graphics and others maintaining the backside of the paper. A collage of tissue and a selection of papers of varying weights and finishes is also applied to build the topography. The surface is sanded in several places for a more distressed effect. Two coats of acrylic matte medium are applied to permanently seal the textured surface.

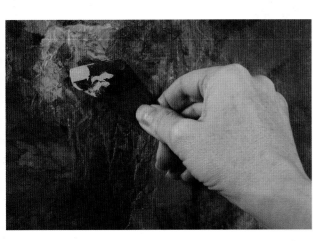

6 Expressive Painting

Acrylic paint is applied to the surface using brushes, a painting knife and a sponge to establish the overall composition and color scheme. The decorative border along the outside is painted with several alternating layers of Burnt Sienna and gold acrylic. The inner frame on the multidimensional panel is also painted with the same color palette to unify the painting and the environment.

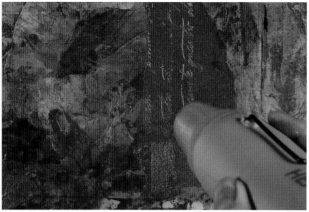

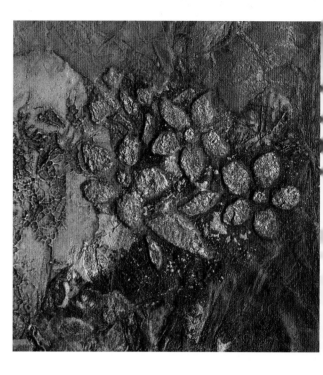

7 Embossed Accents

A rubber stamp with script on it is impressed into an embossing ink pad and applied to the working surface. Before it dries, the ink is covered with gold embossing powder. Excess powder is removed by tapping the panel on the back. A heating element is employed to melt the gold powder, creating an embossed surface. To create yet another dimensional accent, modeling paste is applied through a floral stencil with a painting knife. Acrylic paint is sponged on top to unify the raised surface with the surrounding areas.

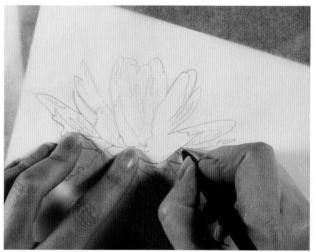

8 Debossed Accents

Modeling paste is applied to the painting with a painting knife. Before it dries, a piece of decorative fabric lace is pressed into the surface. A wash of acrylic paint helps to bring out the debossed texture.

9 Introducing the Subject

A line drawing of a lily is created on tracing paper. The drawing is taped into position on the working surface with painter's tape, and a brown Conté stick transfer sheet is placed facedown underneath the tracing paper. A fine-point ballpoint pen is used to transfer the image onto the surface. (To create the custom transfer sheet, brown Conté stick is applied to layout paper and blended smooth.)

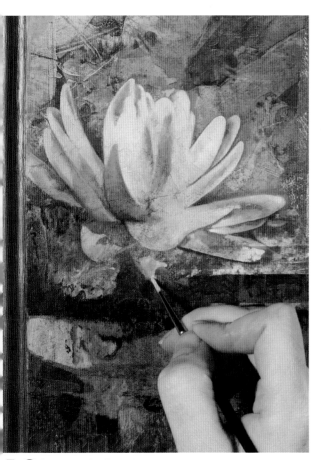

10 Painting the Details

Oil paint and Liquin are used to complete the rendering of the lily. Many of the colors from the abstract environment are incorporated into the form.

11 Creating a Decorative Accent

To represent Excalibur and its magical scabbard, a custom design is created on tracing paper and transferred to the working surface using the process described in step 9. It is later rendered in gold oil paint with a small brush. Gold acrylic is added to the substrate's framework as an inlay.

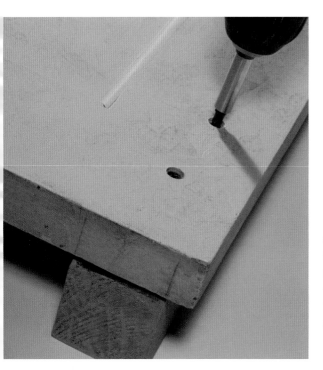

12 Putting It All Together

The decorative panel, the wooden balusters and the painting are assembled and held together from the back with screws. The 30-lb. (14kg) sculpture is securely attached to the panel with screws and polyurethane construction adhesive. To tie the sculptural accent to the painting, copper and gold acrylic paint are sponged on top. The background is further developed by adding turquoise and gold acrylic to the upper area of the composition.

working in multiples and series

When developing works in a series, it is important that the overall theme be engaging enough to sustain the creative process over a period of time. The practice of personal journaling is a wonderful way to explore concepts, topics or subjects of aesthetic interest.

Developing Personal Content Through Journaling

Experiencing the world through the act of journaling produces an authentic perspective. As an active observer, the artist establishes a direct sensory connection with a subject, event or place that cannot be replicated using reference photography alone. The recording of sights, sounds, smells and tactile sensations captures the spirit of what has transpired in a way that is passionate, emotionally driven and vividly compelling. While working in a journal, an artist is able to make connections between the disparate influx of information and stimuli that surrounds everyday life. Whether a ranting of the day's activities or a detailed recitation of a sustained engagement, journal entries provide insight from real life experiences, shedding light on ideas that may have been percolating in the subconscious for years. Wherever I go, I always keep a journal with me. Sometimes I'll write about a magnificent sunset that I've experienced or I may detail the day I spent walking with my daughter telling stories

My custom-painted sketchbook, collage-treated journal, decorative feather pen and handmade bookmark, which features an embossed metal tip-in, are being used for a new series of mixed-media paintings. These will be based on fantasy stories that I am developing in my journals. The metal doorway accents on the sketchbook remind me that every time I open the book, I enter a fantastical world with myriad areas waiting to be explored. The series will generate pieces for a traveling exhibition and lecture, an illustrated book, a print series, and other merchandise and collectibles.

triggered by the engaging sights, sounds and smells that surrounded us. These collective literary snapshots are later expanded upon in the making of my paintings. The dynamic interplay of observation and imagination makes for intriguing picture making.

With daily journaling, small windows of clarity present themselves. Having a repository where these insights can be documented allows for further inspection later on, analyzing where each fits in the grander scheme of things. The experience is like deciphering a story in bits and pieces where you must make the connection between the parts, later arranging the story in a cohesive way so it can be properly told. Like musical improvisation, journal notations set the stage for a more detailed orchestration. Some ideas may be sustainable for only one, two or three paintings, while others best reveal themselves in an entire body of work. With a long-term commitment to the journal process, topics repeat themselves and ideas for thematic works in series or multiples begin to arise. When I feed my journals with content, I become more aware of what is important to me, and more curious to see where the ideation will lead me.

Exploring Alternative Formats and Panel Designs

The creation of a cohesive series requires great forethought as to not only the content of the work but also the layout and presentation that will eventually carry the theme throughout. As the vehicle from which ideas present themselves, the graphic format plays an integral part in the overall pictorial experience, creating a dynamic relationship between the field of vision and the onlooker. When working in a multi-paneled format, it is always best to create a custom design that enhances the eventual interpretation of a work in a meaningful way.

Throughout the development process, it is important to keep in mind how the exterior formatting will affect the imagery placed inside. The shape of the exterior format that will carry an image or several images is very significant, as slight variations in the outer design will not

With daily journaling, small windows of clarity present themselves. Having a repository where these insights can be documented allows for further inspection later on, analyzing where each fits in the grander scheme of things.

only alter the perception and reading but also the flow, continuity and organization of a multi-paneled artistic work. In addition, certain formats can intrinsically trigger visceral reactions. A strong vertical design conveys a sense of power and strength, while a more horizontal presence will bring about a feeling of tranquility. Square formats can be quite dynamic with lots of potential for movement. On the other hand, circular, oval or arch-shaped designs offer a nice break from the grid, creating an interesting tension when placed alongside more rectangular formats. Even the breaks between panels are important areas of transition, where the figure and ground both contribute to the overall design and communicative power of a multi-paneled image.

Incorporating Architectural Accents

For an engaging array of decorative details and effects, chisels, routers, rotary tools, power drills, circular and table saws and the like can be employed. Custom inlays etched into the surface add intriguing linear detail, while decorative borders establish provocative transitions when it comes to panel juxtaposition and layering. Carved add-ons and accents create depth and visual interest, and decorative hinges assist in attaching adjacent panels, creating one cohesive piece of art. I absolutely love incorporating an architectural sensibility in my work and am intrigued by the way the eye can be manipulated through a constructive approach to panel design.

A sequential series derived from my journal notations appears in the sketchbook. The featured spread shows a gesso-textured, mixed-media painted background, a gel medium debossed and painted tip-in, and a die-cut corner end flap that can be opened to reveal additional works in the series.

To establish a sense of balance, unity and visual rhythm, a grid system can be employed, assisting in the establishment of natural relationships between panels. Historically, the great master artists often used grids to create eye flow and visual harmony. Early practitioners looked towards the Fibonacci number sequence to reveal a Divine Proportion between all elements in nature. A ratio of 1 to 1.618 was used as the underlying geometric structure for artistic works. Even today, this Divine Proportion is used in art, architecture, design, film and music to create a natural rhythm that is not only aesthetically pleasing but innately appealing to the senses. When it comes to alternative formatting, a grid system is a great way to explore architectural design options for both multi-paneled works and works in series.

Presentation and Graphic Organization

Whether presented in a picture-driven book, on the Web, in an interactive format or on the walls of a gallery or museum, a series needs to have a cohesive organization that runs through the presentation of the panels, directing the eye throughout the body of work in a controlled, message-driven fashion.

For pre-visualization purposes, much can be learned from the art of storyboarding. At the concept sketch stage, the process allows for the editing, sequencing and graphic organization of works in series.

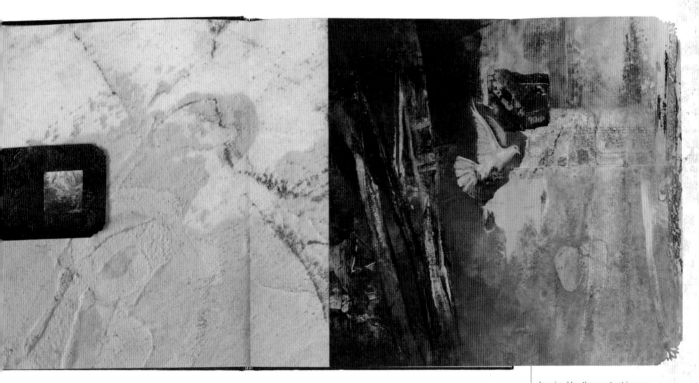

Inspired by the content in my journals, the painted pages of my sketchbook often act as a springboard for larger artistic works and series. A page marker is textured with molding paste, die-cut corners and an inset made from a self-leveling clear gel and acrylic. Magnets attached to the reinforced back clasp the marker to the page.

Preliminary compositional sketches can be put up on a wall and analyzed as a whole, addressing issues of point of view and perspective, scale, relative proportion, repetition and rhythm, pacing and flow, thematic tie-ins and overall unity at an early stage in the process. Whether a series is representational, conceptual or abstract, looking at works from a storyboard approach allows for a more visually cohesive arrangement.

By playing with the framework and organization of works in multiple and in series, artists can create provocative, thought-provoking and visually compelling environments that reveal a concept, subject or theme in an engaging, emotionally stimulating way. Multi-dimensional, multi-paneled works presented in a series open the door to a unique pictorial experience, taking the viewer on an imaginative, intimate journey through the eyes of the artist.

As the vehicle from which ideas present themselves, the graphic format plays an integral part in the overall pictorial experience, creating a dynamic relationship between the field of vision and the onlooker.

Title: Poetry in Motion 1, 2 & 3
Size: 11" × 11" (28cm × 28cm) triptych
Mediums: acrylic, modeling paste and gesso
Techniques: painting knife, spattering, dripping and sponging
Surfaces: Masonite panels

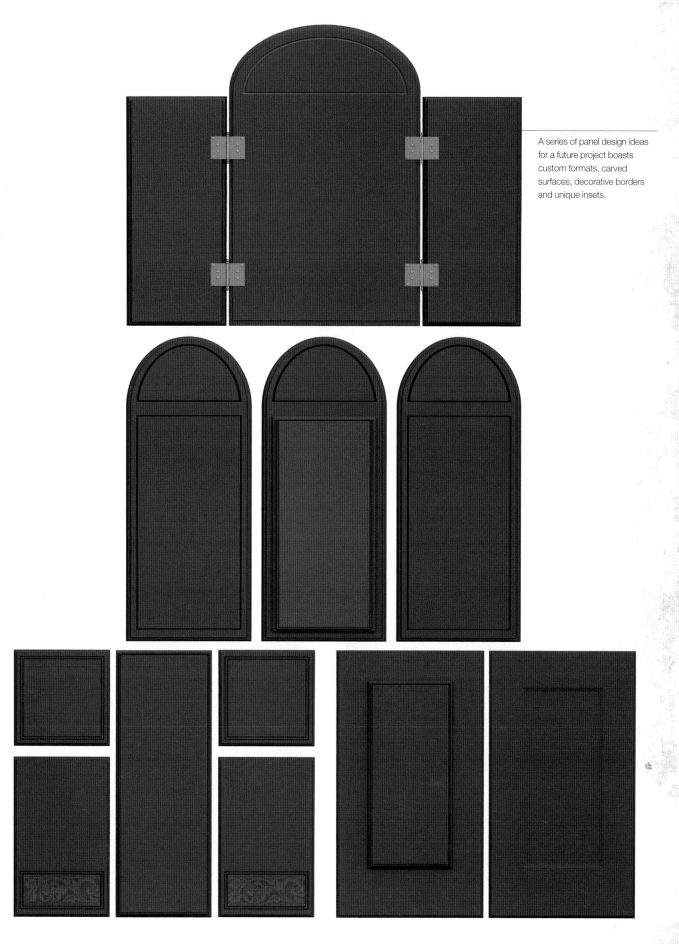

A series of panel design ideas for a future project boasts custom formats, carved surfaces, decorative borders and unique insets.

creative self-promotion and presentation

In a highly competitive global marketplace, it is essential for artists to know and understand who they are as creative individuals before they begin to announce their work to the world. If artistic endeavors are to be authentic, they have to grow from a place that is genuine. Evaluating and defining oneself as an artist requires honest and deep introspection with an ongoing commitment to staying true to the soul of one's work.

Establishing a Voice of Authenticity

For a long-term, rewarding career, artists need to take control of their destiny by shaping their careers to enrich their lives as creative beings. They need to have clarity about what their work is about and where they want to position it in the marketplace. If artists allow the market to overshadow and cloud their vision, they will no longer be in control of their creative path. When a market dictates the journey, the struggle becomes a battle with constant shifts and changes. In the end, no solid foundation is established and creatives find themselves spending their careers working hard at getting nowhere. Instead of looking to the market for a directive, artists need to look inside themselves. The launching of an authentic, creative self into the marketplace is like reaching into one's soul and pulling out a seedling that is true to its core. If firmly planted into the ground and properly nourished, it grows with deep-set roots into an amazing tree, providing life-giving oxygen, fruit and shelter to everything that crosses its path. If artists can stay true to themselves, they will ultimately pave the way for a career that will sustain their passion for the duration of their lifetime, making an impact on generations to come. By establishing a clear directive that comes from a place that is authentic, artists create a road map for success.

Developing Signature Communications

To call attention to their brand, artists are embarking on engaging, thought-provoking, signature communications that create a custom-tailored experience, establishing a long-term, lasting connection with a targeted audience. Active engagement, interaction and participation with a promotional endeavor encourage the recipient to experience an artist's vision in a memorable way. A strategy-based, message-driven approach is at the forefront in creating artistic distinction in the marketplace. From print and broadcast to electronic media, creatives are penetrating a market on many fronts.

When it comes to print initiatives, artists are employing unconventional formats and unique constructions to make an audience stop, look and listen to what they have to offer. We are seeing more and more custom-built portfolios with unconventional surfaces, alternative bindery, clever inserts and engaging add-ons. The eye-catching design and unique look of a custom book communicates an artist's creative personality in a way that is provocative and memorable. Innovation in presentation and approach has a tremendous impact on perception and market value, putting only the best work top of mind. The old black flipbook portfolio with a handle is no longer an option when it comes to establishing a distinctive presence in a competitive, overly saturated marketplace. My custom-built book reflects my brand and image-making sensibilities. The embossed, three-paneled portfolio is accented with ornamental hinges and a treated metal accent. Once opened, it rests on a decorative spine. The cream paper interior is made to be easily interchangeable with detachable signatures that feature both word and image. Throughout, custom die-cuts reveal imagery and key messaging underneath while signature tip-in images printed on watercolor

Evaluating and defining oneself as an artist requires honest and deep introspection with an ongoing commitment to the process of staying true to the soul of one's work.

My custom-built wooden portfolio has an embossed surface accented with a gold and copper patina finish. A gold and black rope knotted at the ends serves as a bookmark.

A simple, clean design is used for the homepage of my portfolio website www.cyrstudio.com. My tagline—think, create and inspire—becomes a set of rollover links to access relevant information.

INSPIRE
books
articles
lectures & workshops
exhibitions

CREATE
portfolio
sketchbook
merchandise
stock

LISA L. CYR

THINK
biography
press
contact
blog
fan page

The portfolio link uses a set of iconic images each accented by an inspirational quote. The linear format keeps the design clean and the message clear and consistent throughout.

INSPIRE

CREATE

"CREATE FROM THE HEART,
STRIVE FOR GREATNESS,
AND SPEAK TO THE CULTURE
IN WAYS THAT INSPIRE
AND MOTIVATE."

THINK

Once an icon is selected, the full image is presented, including the title and detailed information about the size, mediums and surface of each work. An insightful statement about the creation of the piece is also included.

INSPIRE

CREATE

"THE ARTISTIC PROCESS IS A JOURNEY,
A TRUE DISCOVERY OF SELF.
THE MORE I CREATE, THE BETTER I
UNDERSTAND MYSELF AND THE
DIRECTION I MUST FOLLOW."

THINK

BACK

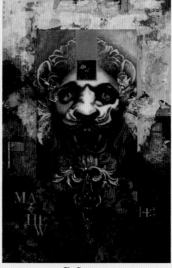

The Courageous
19" x 30.25" x 2.5"
acrylic, oil, collage & assemblage on
canvas over masonite & board with wooden framework

Inside the tri-paneled, wooden exterior is a series of signatures bound with embroidery thread that is braided and wrapped with copper wire. This allows easy access when changing images in the book. An artist profile, various mixed-media works and a biographical sketch are inside the portfolio.

The ink-jet printed portfolio can be easily pulled out, updated and replaced. Velcro is used for ease of use. A recessed area in the back houses a mini audio-video presentation of my portfolio and working process; motion and sound help to elevate the experience. Visit cyrstudio.com/workasplay.html to see the online presentation.

paper establish engaging raised surfaces. In my paintings, I love to create inlaid boxes and raised panels. The architecture and the production aspects of my one-of-a-kind portfolio reflect this passion. I also have several mail-away portfolios that share the same formatting as my main portfolio, but in a smaller scale and with a different binding. My mini portfolios come in a painted, die-cut box that is held closed with a handmade sculpted accent. Also included in the package are an introductory cover letter printed on cream, custom-designed business stationery that boasts a cropped, iconic tip-in of one of my paintings, my oversized business card printed on heavy watercolor paper in a cream-colored sleeve with the same matching tip-in, a comment card, leave-behind samples of my work and a self-addressed stamped envelope. It is mailed in a box covered with my signature wrapping paper and a custom label. I use my mail-away portfolios to introduce my work when I can't show my main portfolio in person. All of the custom treatments are highly representative of my brand and

make a first impression that is genuine and unique to my work and process. As the vessel for content, the presentation of an artistic portfolio has truly evolved, embracing a more message-driven, brand-savvy design.

Public relation efforts, networking at tradeshows and involvement in professional associations, organizations and conferences also go a long way in building brand recognition and establishing long-term relationships with a targeted audience. Every time I announce new work or an upcoming book, I send out a promotional piece to obtain print features and reviews, broadcast media coverage, exhibitions, events and speaking engagements. To ensure the promotional initiative is truly extraordinary, I collaborate with some of my favorite designers as well as with paper companies, creating a group-inspired presence.

In addition to being successful at gaining recognition for my work, my promotional endeavors have won awards for self-promotion and been featured in books and magazines for their promotional impact. This attention further builds my brand as an artist as well as the identities of the other brands that have collaborated in the project. For a global array of promotional initiatives, check out my special production cover books entitled *The Art of Promotion* and *Innovative Promotions that Work*. The strategy and production-based innovation featured in the books reveal new ways to captivate an audience, building brand recognition and market value.

Although new business development is always top of mind, it is also important to nurture the relationships that are ongoing. During the year-end holidays,

I always like to send keepsake gifts to clients who have graced me with opportunities to do the work I love. These initiatives have allowed me to explore my work as prints, calendars, journals, note cards and bookmarks. Many of the products can be later used as merchandising elements that carry the brand to a larger, more diversified audience. Whether through art licensing endeavors or self publishing and distribution through retail and ecommerce sites, artists have an opportunity to showcase their work to the culture in myriad ways.

With the flexibility and high quality printing available through desktop technology, many promotional works as well as merchandising items can be produced in-house using ink-jet printing on both porous and nonporous surfaces. The interior of my custom portfolio, my mail-away portfolios, my stationery system, my business forms and every major, award-winning promotional piece that goes out on my work was produced in my studio using my Epson ink-jet printer. For larger runs, print-on-demand vendors offer quality digital printing that can be affordably purchased by item without the financial commitment to a large inventory, conveniently allowing artists to produce only what they need at any given time.

Creating a Dynamic Presence

As a result of technological advances, alternative promotional and presentational outlets are also available through the Internet, offering sound, motion and interactive elements. Portfolio-based websites, online video biographies, animated slide presentations, electronic books, ezines and artist blogs allow instant, cost-effective communications to a worldwide audience. My online portfolio shares many of the same aesthetics as its print counterparts, including the overall word and image format, color schema and key word navigation that help to reinforce my tagline: think, create, inspire. I also participate in several group portfolio sites which direct traffic to my work from a visitor's interest in a larger collection of artistic works. Many of these sites have profiled my work as well as called attention to the various events and other news that surround what I am doing as an artist. In addition, I've used the Internet to provide insight into my work, process and approach. Online demonstrations, podcast interviews and event coverage give a window into my world as an artist. I also have an artist's blog where I announce things that I am involved in. The blog is linked to my various author pages available

With the proliferation of social media, artists are finding even more opportunities for their work to penetrate the marketplace. No longer limited to geographic location, online communities and groups can span continents, cultivating a vibrant and robust dialogue.

through my publishers and other major online sellers. Whenever I make an entry to my blog, the story is distributed through syndication to a series of outlets that sell and profile my work. The ability to go viral with an initiative allows for the distribution of a message to the masses, hitting markets that are broad reaching.

Promotion Through Social Media

With the proliferation of social media, artists are finding even more opportunities for their work to penetrate the marketplace. No longer limited to geographic location, online communities and groups can span continents, cultivating a vibrant and robust dialogue. To build their artistic platform, artists are actively participating in various business as well as social networking sites, linking them to their portfolio online, group sites, blog and other venues that feature their work on the Web. Like many artists, I also participate in the social networking process, expanding my online presence to reach a diversified audience. I find the exchange to be extremely rewarding. Sharing one's vision of the world attracts other like-minded people. With an ongoing commitment to the dynamic process, opportunities for collaboration and other ventures begin to arise. Actively pursuing relationships that promote brand recognition builds market value as time goes on, creating even more rewarding work that further disseminates what has already been defined.

Like no other time, we have an amazing amalgam of promotion-based media from which to share our vision. It is important that we be authentic in our approach, producing meaningful work that uplifts, inspires and motivates others to join in the conversation. When a small stone is cast in a lake, concentric ripples are made, altering the waters around its wake. Whether a little ripple made by a small stone or a grand wave created with a huge boulder, the world is affected in some way by the effort. There is an opportunity to create a content-rich cultural exchange, lifting the bar to a greater standard of excellence to create positive change in the world around us.

manufacturers, resources and suppliers

3M
3m.com
clear transparency film

A.C. Moore Arts & Crafts Inc.
acmoore.com
hand-held punchers and die-cutters, embossing stylus, wire, eyelets, grommets and brads, offset pastry spatula and other pastry decorating supplies

Activa
activaproducts.com
foliage preserver

Albums, Inc.
albumsinc.com
Sureguard Retouchable II: vellum fixative

Ampersand
ampersandart.com
dimensional Clayboard panel

Books by Hand
booksbyhand.com
bookbinder's glue: pH neutral PVA

Caran d'Ache
carandache.ch
Supracolor Soft Aquarelle pencils and Neocolor II Aquarelle crayons

Citra Solv
citra-solv.com
cleaner and degreaser

Clearsnap
clearsnap.com
pigment ink pad

Colour Shaper
colourshaper.com
shaper tool

Crayola
crayola.com
wax crayons

Daler Rowney
daler-rowney.com
Stay-Wet Palette

Dick Blick Art Materials
dickblick.com
white artist's gesso and soft blending stumps

Epson
epson.com
ink-jet printer, flatbed scanner, double-sided matte inkjet paper and Ultra-chrome inks

Fredrix Artist Canvas
fredrixartistcanvas.com
linen and cotton duck canvas

Gamblin Artists Colors
gamblincolors.com
oil paints

Garment District, NYC
fabric, synthetic mesh, decorative fabric lace and trims

General Pencil Company
generalpencil.com
graphite pencils and powdered graphite

Golden Artist Colors
goldenpaints.com
acrylic paints, acrylic gel medium, GAC 200 and GAC 500 acrylic polymers, crackle paste, molding paste, self-leveling clear gel and digital grounds

Graphtec America Inc.
graphtecamerica.com
Craft Robo stencil cutter

Hewlett-Packard
hp.com
black-and-white laser printer

Home Depot
homedepot.com
Masonite, wood, mill-finished textured aluminum, construction glues, wood filler, building materials and equipment

L. A. Gold Leaf
lagoldleaf.com
imitation gold leaf and sizing

Lefranc & Bourgeois
lefranc-bourgeois.com
Conté sticks, aging varnish and cracking varnish

Letraset
letraset.com
press-on type and vinyl letters

Liquitex Artist Materials
liquitex.com
acrylic paints, modeling paste, acrylic matte medium, acrylic gloss medium and varnish and resin sand gel texture

Martin/F. Weber Co.
weberart.com
odorless Turpenoid

Masterchem Industries LLC
kilz.com
stain resistant primer

Nashua
water resistant silver tape

Nicolecrafts
nicolecrafts.com
embossing heat tool

Nova Color

novacolorpaint.com

acrylic polymer matte gel medium

Olde Good Things

ogtstore.com

vintage metal accents and architectural details

Owens Corning

owenscorning.com

polystyrene foam

Prismacolor

prismacolor.com

Nupastel color sticks and colored pencils

Ranger Industries

rangerink.com

embossing ink and powder

Rives BFK

rivesbfk.com

printmaking paper

Rosco Laboratories

rosco.com

FoamCoat

Scotch

scotchbrand.com

painter's tape and clear tape

Sherwin-Williams

sherwin-williams.com

latex-based metal primer

Speedball Art Products

speedballart.com

waterproof ink and rubber brayer

Staedtler-Mars

staedtler.com

technical pencils and Mastercarve artist carving block

Strathmore Artist Papers

strathmoreartist.com

tracing paper, layout paper, charcoal paper, bristol and illustration board

The Compleat Sculptor

sculpt.com

polymer clay and sculpting tools

Walnut Hollow

walnuthollow.com

embossing metal

Winsor & Newton

winsornewton.com

gouache, masking fluid, oil paint and Liquin

artist resources and organizations

Association of Fantastic Art / IlluXCon

illuxcon.com

munchkinpress.com

Acrylic Artist Magazine

artistsnetwork.com/acrylic-artist-magazine

Communication Arts Magazine: Illustration Annual

commarts.com

3x3 Magazine of Contemporary Illustration

3x3mag.com

blog.3x3mag.com

Illustrators Partnership of America

illustratorspartnership.org

International Society of Experimental Artists

iseaartexhibit.org

Society of Illustrators: NYC

The Museum of American Illustration

societyillustrators.org

Society of Illustrators of Los Angeles

si-la.org

Spectrum: The Best in Contemporary Fantastic Art

spectrumfantasticart.com

The Alternative Pick

altpick.com

The Artist's Magazine

artistsnetwork.com/artistsmagazine

The Artist Network News

youtube.com/user/artistsnetwork

Index

Create from the heart, innovate without boundaries, strive for greatness and speak to the culture in ways that inspire and motivate.

Title: Self-Portrait
Size: 8" × 10" (20cm × 25cm)
Mediums: acrylic and ink
Techniques: collage, painting knife, sponging, blotting, dry brush and digital manipulation
Surface: bristol board

About the Author

Lisa L. Cyr is an accomplished multidisciplinary artist and author with a content-driven approach. A graduate of the Massachusetts College of Art and Design (BFA) and Syracuse University (MA), her work has been exhibited both nationally and internationally in museums, galleries, universities and at industry organizations, including traveling shows with the Society of Illustrators of New York and Los Angeles. Her work has been featured in numerous magazines, books and online, including features in *Spectrum: The Best in Contemporary Fantastic Art*. In addition, Cyr's art is included in the permanent collection of the Museum of American Illustration as well as in private collections.

Cyr has authored seven books on art and design, including the mixed-media bestseller *Art Revolution* (North Light Books, 2008). She also writes for many of the creative industry's leading art publications, including *Communication Arts*, *Applied Arts*, *The Artist's Magazine*, *HOW*, *STEP Inside Design*, *ID*, *Altpick* and many others. Cyr speaks actively on self-promotion strategies and marketing for the creative industry, as well as conducts workshops on innovative, mixed-media techniques at professional organizations, universities and trade conferences. Her insightful, thought-provoking lectures, *Work as Play*, *Reinterpret, Reinvent and Redefine*, *The Art of Promotion*, and *Creatively Speaking*, inform, inspire and motivate. Cyr also teaches in several of the top MFA graduate programs in the country. An artist member of the Society of Illustrators in New York City and the International Society of Experimental Artists, Cyr works in partnership with her husband Christopher Short, painter, 3D illustrator and animator.

For more and to connect via social media, visit her website at **cyrstudio.com** and blog at **lisalcyr.wordpress.com**.

Other fine North Light Books are available from your favorite bookstore, art supply store or online supplier. Visit our website at fwmedia.com.

15 14 13 12 11 5 4 3 2 1

DISTRIBUTED IN CANADA BY FRASER DIRECT
100 Armstrong Avenue
Georgetown, ON, Canada L7G 5S4
Tel: (905) 877-4411

DISTRIBUTED IN THE U.K. AND EUROPE BY F&W MEDIA INTER-NATIONAL, LTD
Brunel House, Forde Close, Newton Abbot, Devon, TQ12 4PU, UK
Tel: (+44) 1626 323200, Fax: (+44) 1626 323319
Email: enquiries@fwmedia.com

DISTRIBUTED IN AUSTRALIA BY CAPRICORN LINK
P.O. Box 704, S. Windsor NSW, 2756 Australia
Tel: (02) 4577-3555

Edited by Sarah Laichas
Designed by Guy Kelly
Production coordinated by Mark Griffin

metric conversion chart

To convert	to	multiply by
Inches	Centimeters	2.54
Centimeters	Inches	0.4
Feet	Centimeters	30.5
Centimeters	Feet	0.03
Yards	Meters	0.9
Meters	Yards	1.1

Ideas. Instruction. Inspiration.

Receive a **FREE** downloadable issue of *The Artist's Magazine* when you sign up for our free newsletter at artistsnetwork.com/newsletter_thanks.

These and other fine North Light products are available at your favorite art & craft retailer, bookstore or online supplier. Visit our websites at artistsnetwork.com and artistsnetwork.tv.

Visit artistsnetwork.com and get Jen's North Light Picks!

Get free step-by-step demonstrations along with reviews of the latest books, videos and downloads from Jennifer Lepore, Senior Editor and Online Education Manager at North Light Books.